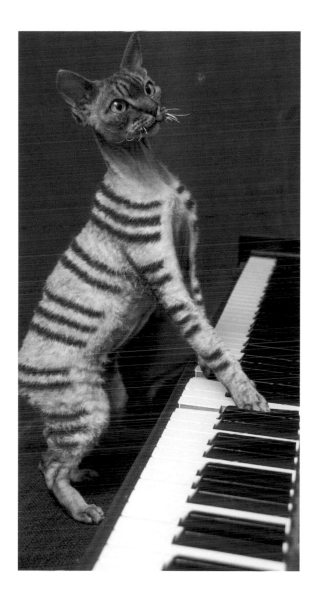

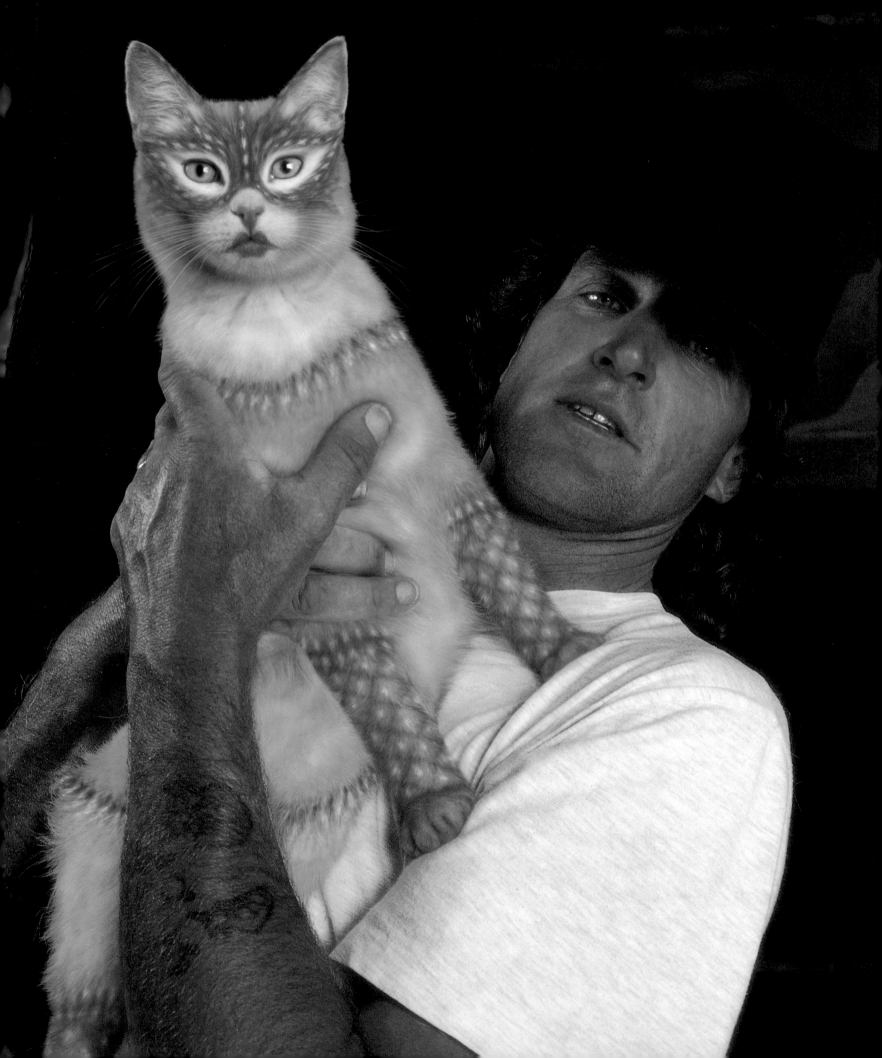

WHY PAINT CATS

The ethics of feline aesthetics

Burton Silver
Heather Busch

Ten Speed Press Berkeley · Toronto

🔟

TEN SPEED PRESS
P.O. Box 7123
Berkeley, California 94707
www.tenspeed.com

Distributed in Australia by Simon and Schuster Australia, in Canada by Ten Speed Press Canada, in New Zealand by Southern Publishers Group, in South Africa by Real Books, in Southeast Asia by Berkeley Books, and in the United Kingdom and Europe by Airlift Book Co.

The moral rights of Burton Silver (as author), and Heather Busch (as photographer) to be identified as creators of this work have been asserted by them in accordance with the Copyright, Designs and Patents Act 1988.

Neither the publisher, author or photographer accept any responsibility for any adverse reactions which may result from the use of material in this book.

No cats were harmed during the making of this book. All artists or facilitators included in the book, with the exception of the two artists on pages 41 & 42, are, or have been members of Artists for the Ethical Treatment of Animals (A.E.T.A.).

Why Paint Cats is a registered international experiment in morphic resonance and is designed to test the hypothesis of formative causation. International Experiment No. 99–306810–8.

Book Layout and design: Heather Busch.
Editorial: Melissa da Souza, Martin O'Connor.

Library of Congress Catalog information is on file with the publisher.

ISBN: 1–58008–271–8

First USA printing, 2002.

Printed and bound in China.

Published with the assistance of the North American Council for the Promotion of Cat Art.

1 2 3 4 5—06 05 04 03 02

FRONTISPIECE: *Tippoo's Tiger*, 2001. Vegetable dye on *Offenbach*, Cornish Rex. S. Tarrant, Wellington.

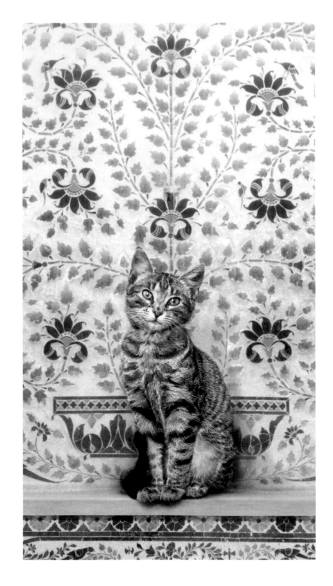

ABOVE: *Pussillamorous*, 2001. Vegetable dye on *Amy*, tabby moggy. I. Lovegrove, Manchester.

For more information on painting cats visit:
www.whypaintcats.com

CONTENTS

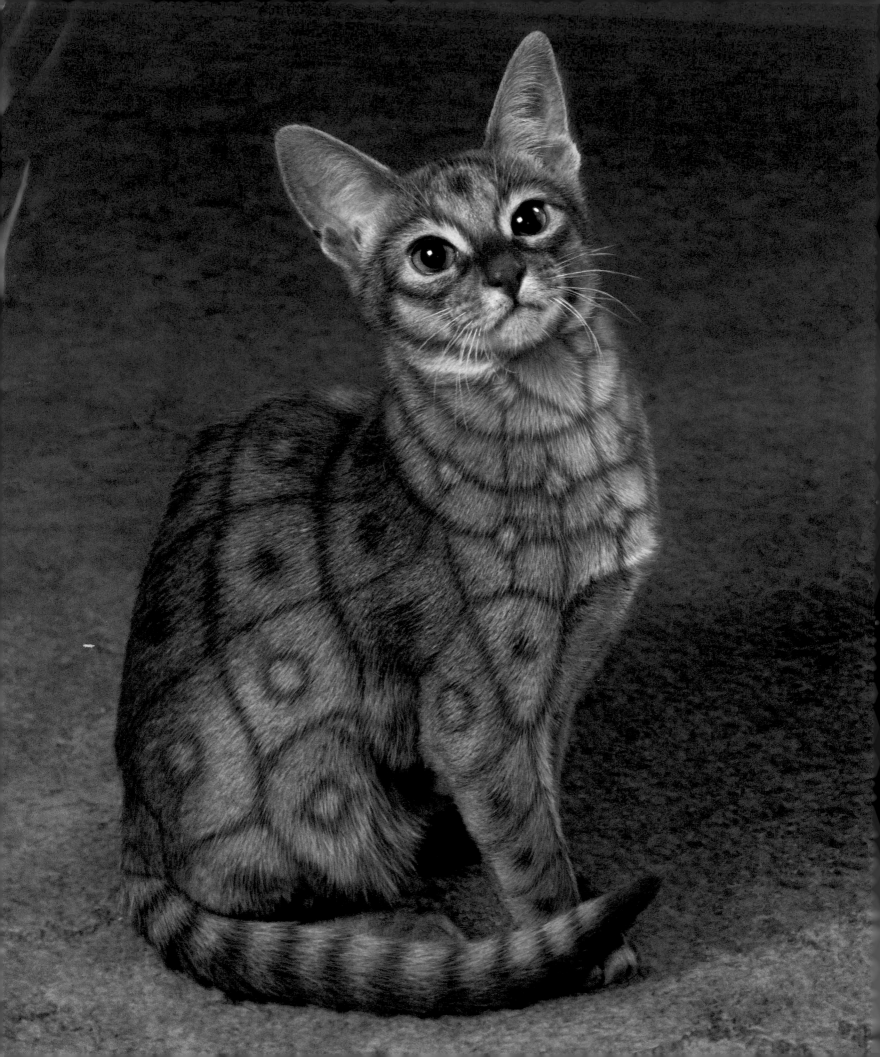

FOREWORD

One year ago a young artist who didn't much care for my observations, described me as "one of those cynical old art critics who have lost their sense of wonder." Certainly I am old, seventy-four is getting on, and cynical? Well, yes, I've been professionally involved in the arts for more than fifty years and there is little new art that moves me anymore. And what about my sense of wonder? Six months ago I might have even conceded that this was lost as well – but then I hadn't yet met Cymbeline.

She appeared silently and without fanfare, as cats do. She was sitting there, staring at me from the end of the path; small, assured and exquisitely beautiful. Her lithe body was covered with a mosaic of large turquoise-tinged diamonds that spread out and enfolded her like the translucent stained glass shapes of a butterfly's wings. A cat, but not a cat – more like some ethereal fairy creature wreathed in a silken cloak. Yet seemingly not conceived by a human hand, for in spite of its symmetry this design was profoundly organic, at once the pattern of a turtle, giraffe and beetle made alive in fur. I don't know how long I stood gazing at her before she finally approached and lightly brushed her azure softness against my leg. What I felt at that moment was more than wonder. It was the profound joy of being in the presence of an artwork so beautifully conceived, so perfectly executed that I was suddenly truly alive.

And then Cymbeline was walking away, pausing, turning and walking back, for all the world like an elegant model wanting me to delight in every nuance of her tessellated finery. With each move she invited a change of perception. Every dismissive flick of her tail, each satisfied stretch, drew me into a new understanding of the feline psyche and moved me on towards a deeper connection with myself. Art can and should move us like this. Without words of explanation, without galleries, without frames and without names, beautiful art can change the way we experience the world – and this new art of cat painting, especially so.

Federico Raggio

LEFT: *Il Senso di Completezza*, 2001. Neutralized peroxide and vegetable dye on *Cymbeline*, Abyssinian. M. Gallani, Bologna.

This work by Isabella Baldassari of Ferrara, Italy, won the Martelli Prize for Contemporary Art in 2001. An earlier work, *Tortellino per sempre*, 2000, which featured an intricate web of delicate pasta patterns on a Cream Tonkinese, was shown at the inaugural International Food Fair 2000 in Sharjah as part of Italy's *New Art for the New Millennium* exhibit. It was awarded the H.B. Saeed Mohammed Al Paganbani Prize for Decorated Food in the mistaken belief that Italians eat cats.

PREFACE

BELOW: Postage stamps from Ayuba reflect the importance of the cat face-painting tradition in this independent African territory.

Cat painting, once the preserve of a few Midwest American artists, is becoming so mainstream that it's possible to see a cat being styled and painted in a specialized beauty salon or competing for "Best Painted Cat" at a pet show. In other cultures it's not so new. People paint their cats in India and Japan and if you traveled to Ayuba, an independent territory of Botswana in the Okavango Delta, you would find the local Bayeyi people using bark dyes to paint butterflies on their cats' faces. For artists in the West, the unexplored potential of the feline canvas is a new fascination, while for the Bayeyi, embellishing their cats' fur is a centuries-old tradition based on the belief that a butterfly drawn on the feline face will repel the evil spirits of the night.

In San Francisco, you can drop off your cat with the local cosmetician-turned-cat painter who will use the latest electrostatic brushes and dyes to decorate your Fluff with a colorful Tibetan mandala. This takes just two hours. In Ayuba it takes a Bayeyi elder two *days* of gentle brushing to complete a design and before he can start he must await a sign from the cat that it is ready and willing to proceed. Their methods are based on a deep faith in the cat as a spiritual force for good. In our modern world how we behave towards the animals in our care is often determined by ethical standards that are not embodied in any belief structure, but rather need to be imposed from the outside by organizations like Artists for the Ethical Treatment of Animals (A.E.T.A.).

It is our hope that these photographs of cat paintings and interviews with artists and guardians will help to generate a wider community of artistic interest and thereby go some way towards establishing a more deep-seated and internalized appreciation of the feline aesthetic. Of course it is vital that a well-conceived ethical code of conduct forms the basis of the cat painting movement and we applaud the vision and methods of A.E.T.A. in striving to bring this about. However, no amount of sermonizing in monthly newsletters can replace the deep sense of moral certitude and intuitive ethical understanding that rises out of a strong attachment

between human and feline. What stunts this attachment more than any thing is self-interest, and some artists could be mercenary enough to realize that the feline canvas comes with a patron already attached in the form of the cat's guardian, who is often willing to pay large sums in return for the pleasure of "owning" a redesigned cat. Is the inevitable result the commercialization of cat art and the concomitant exploitation of the cat, or will the depth of ethical concern reflected by the artists and guardians in this book result in a more positive outcome – a new feline aesthetic in which the needs and rights of the cats in our lives are every bit as important as ours? As the Cheshire Cat told Alice, where you end up "...depends a good deal on where you want to get to."

Burton Silver and Heather Busch
Wellington, 2002

BELOW: A Persian is clipped and finger painted with a simple Tibetan mandala design in a San Francisco beauty salon. Cost: $650.

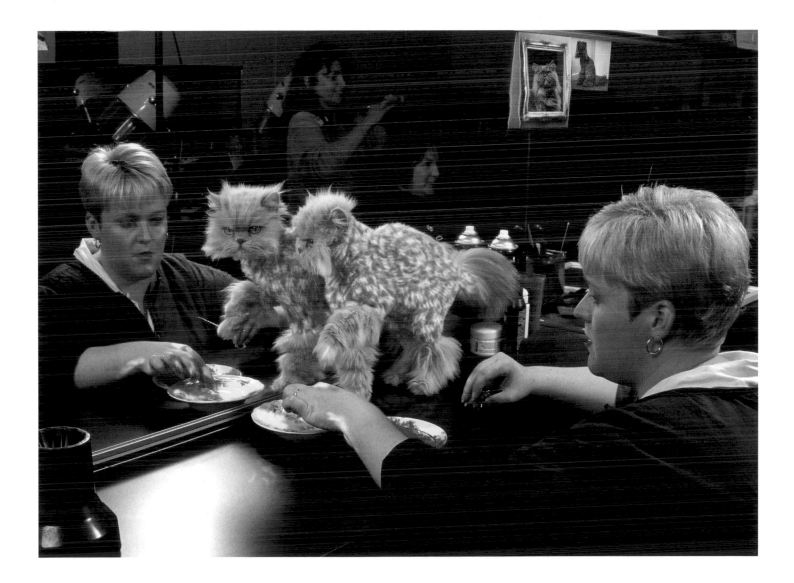

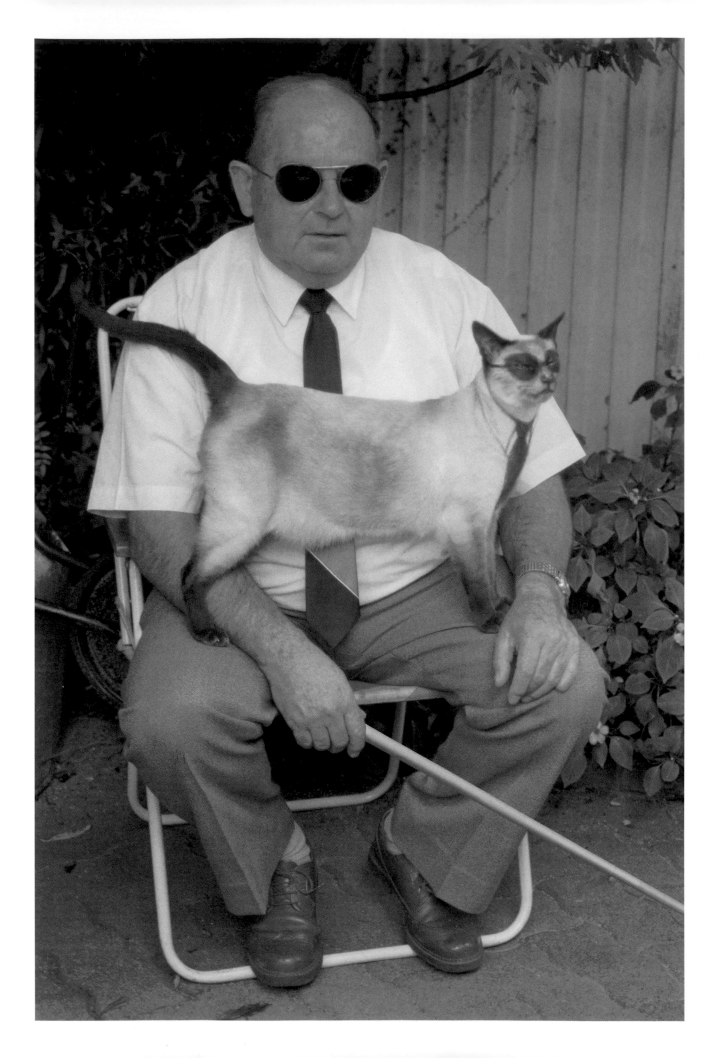

INTRODUCTION

The earliest known photograph of a painted cat was taken in 1955 in the small Midwest American town of Patriot not far from Cincinnati. It shows Harvey Berryman, a retired, partially blind roadhouse owner sitting with his blind Siamese cat, Heidi. According to Harvey's son, his father had his mother paint the dark glasses on Heidi with her black hair dye every month or two so that folks would know that the cat was blind. Harvey could signal his own sight problem by wearing dark glasses and by carrying a white cane, but travelers who stopped at the roadhouse had no way of knowing Heidi was blind and often frightened her because they didn't realize she couldn't see them.

Heidi became quite well-known and it seems likely that it was she who inspired a group of women in the nearby town of Florence to begin painting cats and dogs with flowers in order to raise money for an animal shelter. In fact it's possible that today's culture of concern for the welfare of painted cats may have been sparked by the original altruistic reason for painting Heidi. Certainly the Florence group appear to have insisted that cat painting should benefit the cat in some way and at one stage wrote a letter to the local press decrying the fact that a Cincinnati music store had a cat, with its feet dyed blue, playing among the guitars in the window. The window was emblazoned with a huge sign saying, "Go cat go!" which was a line from the 1956 hit song, *Blue Suede Shoes*.

It is generally acknowledged that the ethically acceptable techniques for getting cats used to being painted have come from the East. As early as 1964, at a cat show in Dayton, Ohio, fabric artist Muriel Gordon demonstrated the pre-paint petting exercises she had learned on a trip to India, and by the late seventies a few artists were traveling to Japan to study the cat face-painting procedures used in Noh theater. Even so, during the eighties cat painting continued to be marginalized – at best enjoying the status of a craft. It was not until the advent of the electrostatic airbrush and the rise in popularity of the No-Frames art movement that the cat as canvas began to excite serious interest.

LEFT: Harvey Berryman with his blind cat, Heidi in the garden of his Patriot, Ohio roadhouse in 1955.

A necktie to match Harvey's was sometimes painted on Heidi for fun, but the dark glasses were a serious attempt to warn strangers of her blindness. This is the first known example of a cat painting designed with the welfare of the cat in mind and may have been the genesis of the strong ethical code that exists among cat artists today.

ABOVE: Cat painting has been practiced in the East for centuries. In Japanese Noh theater, cats who usually play the part of demons won't tolerate real masks and must have them painted on, while in the north of India, temple cats are routinely painted with sacred symbols.

The ever-increasing range of non-stick water-based dyes now available through the hair-styling industry and the latest airbrushes that use static electricity to draw up small tufts of fur for individual attention have dramatically broadened the scope of fur dyeing techniques. This has made cat painting more accessible to a wider range of artists who, thanks to the influence of exponents of the ephemeral such as sculptor Andy Goldsworthy, seem willing to accept the transient nature of the art in return for the joy of seeing their creations come alive with every new twist and turn of the feline body.

But while the appropriation of a live animal in the name of art may offer the key to hitherto unimagined realms of aesthetic pleasure, it also entrusts its manipulator with the responsibility of ensuring its welfare. The artists' own ethical organization insists that they make certain the cat remains physically unharmed before, during and after the painting process,[1] and also that the completed work does not demean or objectify it.[2] Almost all artists belong to the organization and claim to follow its basic tenant – that a work of cat art must benefit or upgrade the cat in some way.[3] While the maintenance of such principles are an undeniably positive feature of the cat painting movement, they have been criticized for leading to, "...an expedient over-emphasis on ethical cost analysis at the expense of robust aesthetic dissertation"[4]

Certainly cat artists have been quick to manufacture, and some would say shelter behind, stylistic monikers which could be seen as claiming a higher purpose for their work. This is nothing new in today's art world, where theory has become marketing statement and the need to strike a politically correct pose is paramount. The unseemly jostling for position, so typical of a new art movement and especially one which is still as relatively free of curatorial constraint as this one is, will inevitably produce an over-proliferation of schools and styles. While many of these can be expected to fall by the wayside or be absorbed into other groupings, those that appeal to the artistically conservative are most likely to remain the mainstay of the cat painting scene for some time to come.

For example, the purely aesthetic styles such as the Nouveau Classical and Classical Fabricationist that are concerned first and foremost with the enhancement of the feline form, have attracted not only exponents of representational landscape, still life and portrait, but also designers, interior decorators and even hair stylists. It is this group that has been largely instrumental in supporting cat-painting competitions at cat shows, which in turn have contributed to the success of such spin-offs as

[1]Rule 7a, Rules of Conduct (Revised 1999), Artists for the Ethical Treatment of Animals. [2]Rule 7d. [3]Rule 1a. [4]Huges, R. Towards a new Feline Aesthetic, Swallow Press, Cambridge, 2001.

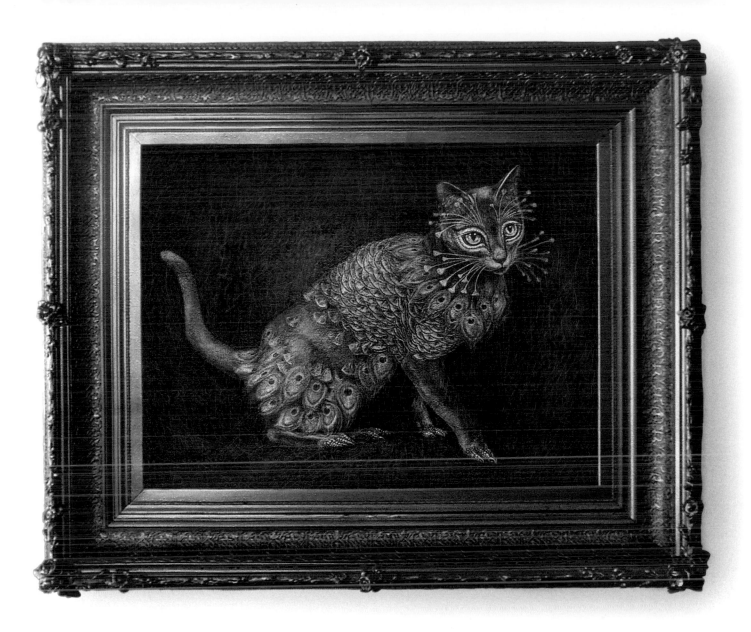

cat-painting kits and cuddly Colorcats® for Children. However, there are many cat painters who worry that the commercialization of their movement may trivialize the serious pro-feline messages they hope to promote, or worse, lead to the exploitation of the cat.

More importantly perhaps, are those who wonder if their art, having found expression on the living feline form, has begun to redefine what cats are and what they may become. When Guiseppe Maria Crespi painted his fantasy peacock-cat nearly 300 years ago, it was just that – an unrealizable fantasy. Today we live in a new world, a world where genetic engineering waits eagerly on the doorstep, ready to change yesterday's painted cats into today's realities. But whether life will imitate art – and science will transform our fundamental notions of what it means to be a cat – must ultimately depend on whether we decide to leave the cat flap open or closed, or maybe, slightly ajar.

ABOVE: *Pavonatto*, c. 1714. Museo Nationale, Pisa.[1]

Guiseppe Maria Crespi, a painter of the Bolognese School, is reputed to have dreamed of this beautiful hybrid before painting it for his daughter, Lucrezia nearly 300 years ago. The cat's sad demeanor has often been interpreted as a prophetic warning against genetic modification.

[1]Reproduced by kind permission of the Museo Nationale e Civico di San Gedeone, Pisa.
For more information on painting cats visit the website at: **www.whypaintcats.com**

KATE BISHOP

~ Artist

KINETIC OBSERVATIONALISM

*"As the cats move about in a confined space, the images
merge… in a vast orchestration of rapidly-changing random forms… "*
~ Art Critic

Kate Bishop's bold kinetic vignettes rely on their transient and unexpected nature for effect. By applying simple monochromatic forms to several cats, she is able to introduce movement and change into two-dimensional art. Working quickly using stencils and an electrostatic airbrush, and utilizing her intimate knowledge of feline social distance, she positions the images at the correct height so they can interact with images on the other cats. "As the cats move about in a confined space, the images merge, becoming partially obscured and transformed in a vast orchestration of rapidly-changing random forms, each one representing the sum of its infinite possibilities." Critic Peter Stace went on to describe the experience of viewing *Heavenly Bodies* as "…potentially transcending," and wrote that the work, "…represents a significant advance in the celestial-bestial chromosphere."[1]

Bishop agrees and points out that her installations are designed to upgrade cats by showing that their special sensitivities enable them to tune into the cosmos. "They are mysterious creatures," she says, "because they actually understand the mystery." This aspect is also explored in her latest work, *Gnomadic Notions*, 2002, in which cats in an upright position are painted to represent garden gnomes. Their interactions imbue the small garden setting with a mystical feeling as though the garden is alive with mythical beings, which in turn proves the existence of other worlds.

LEFT: *Heavenly Bodies*, 2001. Organic peroxide on *Blackie & Patch*, black & white Moggies. D. McGill, Edinburgh.

Not all of Bishop's celestial works lack a practical side. In *Galilean Galactacus*, 1999, inspired by Galileo's love of cats, she traced fine white lines from the tips of a black cat's ears, down its back and around the base of its tail. By orientating the cat's annular ring accurately on a moonless night, and slowly rotating its whole body in a counterclockwise direction, it was possible to sight along the lines and correctly measure the azimuth of Venus and the moon at setting time.

[1] Stace, P. Feline Kinetic Design as Installation Art, 1999-2001. *Journal of Applied Animal Aesthetics, Vol. VII, 2001.*

PAULA CARSON
~ Artist

NEO-TOTEMISM

" ...I only work with cats who have a sense of the dramatic and can engage with the viewer on a primal level." ~ Artist

Paula Carson travels the world painting cats for the rich and famous and that includes a couple of felines from a royal household. She is best known for her bold totemic designs which are acclaimed as much for the proficiency of their integration with the cat's form and fur as they are for their embodiment of political statement. However, her works rely for effect not only on their recontextualized symbolism, but also on an ability to engage beyond the first juxtapositional shock. "There has to be a continuing dialogue," she says, "That's why I only work with cats who have a sense of the dramatic and can engage with the viewer on a primal level."

As far as the critics are concerned, she has more than achieved her purpose. Extolling the virtues of *Powwow*, critic Joan Dent wrote; "By clothing the cat in traditional indigenous regalia, Carson enfolds the modern within the ancient – the ubiquitous and commercial in the resplendent raiments of the rare and the deeply meaningful. The costume is so skillfully tailored, the fit so perfectly achieved that the mantle of spiritual knowledge passes seamlessly and imbues the feline presence with an uncanny sense of wisdom. This is an uplifting and ultimately revealing work that not only encourages new insights into our cats' psyche but also forces us to question whether the growing use of Native American iconography in cat art is simply an appropriation of indigenous culture in order to assuage imperialist guilt or a vital catalyst for the reintegration of ancient beliefs which transcend modern realities." [1]

RIGHT: *Powwow,* 1998. Vegetable Dye on *Strato*, Champagne Longhair. M. Jackson, Los Angeles.

OVERLEAF: *Power House Glide,* 2001. Non-toxic dye on *Trixanna*, Seal Lynx. Sir & Lady John Chatsworthy.

Paula Carson's most recent work is concerned with the imposition of totemic invertebrate markings onto the feline form as a way of illustrating interspecies power dichotomies. *Power House Glide* is a good example of this but in another well-known work, *Nippy Nip, 2001,* she adorned the side of a Tabby with a bright red crab which scuttled sideways as the cat moved forwards. "The effect is arresting and the portrayal of political expediency and defended privilege is clearly drawn." [2]

[1] *Dent, J.* Crustaceans, Molluscs and Masks. Towards a New Understanding of the Feline Imperative in Neo-Totemist Design. *Paper delivered to the Annual Cat Canvas Conference, Berkeley, 2001.* [2] *ibid.*

SALLY SMITH
~ Artist

PALLIATIVE SYMBOLISM

" It gives them a sense of purpose and well-being, and then they have the thrill of the painting jumping into their lap." ~ Artist

Sally Smith, who lives in Sydney, Australia, specializes in bold symbolist designs which contain powerful therapeutic messages. She came to cat painting after five years as a professional body artist at Bondi Beach and now works exclusively with organizations that offer feline therapy to those in need. Smith is best known for her innovative heart designs, which have been used extensively by Blue Heart Inc., an organization for men who want to learn to love, and the Australian nurses' White Heart Guild.[1] Working for groups like these has given her art new purpose: "Now," she says, "unless my art has the potential to transform people's lives, I won't do it." Indeed, the heart is recognized as one of our most potent healing symbols and when integrated into the fur of a living cat (an animal widely accepted as one of the four natural healers, along with the dog, horse and gerbil), its palliative potential is greatly magnified.

Sally compares her painted cats to guide dogs for the blind by pointing to the liberating effect they can have on sensuously challenged males. "Many of the guys who join Blue Heart groups have no idea how to stroke a cat let alone a woman, but by working over the hearts – they're like arrow heads that show men the correct direction to follow and how hard to press – they quickly achieve acceptable levels of sensitivity." Of course she's the first to admit that the loveable Irish Shortears are a vital part of the process. "Men are captivated by those great big nurturing eyes and the very loud purr," she confides. "What's so wonderful is that the cats

LEFT: *True Blue,* 2000. Vegetable Dye on *Jacko*, Brown Silver Shaded Irish Shortear. W. Stone, Sydney.

The Irish Shortear, seen here with Bill Stone, President of *Blue Heart Inc.*, was bred for its placid personality and the lightness of its coat – qualities that make it ideal for painting. Most Shortears, which are a cross between a Scottish Fold and a Burmilla with a partially dominant macro-retinal gene, have large protuberant eyes. This gives them a very wide angle of vision and may account for their relaxed behavior in stressful situations. They have a particularly loud purr and a positive response to frequent stroking, showing no tendency towards irritability if over-stroked.

[1] Smith has also accepted commissions from the Pink Ring Campaign, for male health awareness in rural N.S.W., and Golden Carrot, an organization devoted to the rehabilitation of maltreated horses.

RIGHT: *Big Art,* 2001. Neutralized peroxide & vegetable dye on *Flo,* Silver Tabby. L. Bates, Sydney.

ABOVE: Flo's guardian, Lenny Bates, a volunteer for Pets On Wheels, spends at least one hour prior to a hospital visit with pre-paint grooming exercises. Lenny likes to cultivate an involvement with process by letting patients add to Flo's black tabby markings, thus he needs to get her acclimated to being brushed before they start in on her with their non-permanent black dye creations.

really enjoy the attention. But then they're bred for it, aren't they?" she adds as an afterthought, with perhaps just a hint of discomfort.

Yet Smith feels no need to justify her use of the feline fur canvas for the White Heart Guild of Nurses.[2] She points out that the cats they use as part of the Pets On Wheels scheme are very outgoing and love all the petting they receive from the patients they visit. Studies show that cats have a positive effect on human emotions and physiology, which can significantly benefit our health. "So," says Smith, "when patients see that big moon face staring up at them they intuitively recognize the symbol of the nurses' guild and can more easily receive the cat as a professional healer." Patients are also encouraged to take part in the painting process, often helping to do the touch-up work or selecting new color combinations. "It's involving," she claims, "like choosing clothes for a child — it gives them a sense of purpose and well-being, and then they have the thrill of the painting jumping into their lap ."

[2] The white heart became the official symbol for the International Council of Nurses in 1999 and was adopted by the the Feline Division of the Australian Guild of Nurses in the same year.

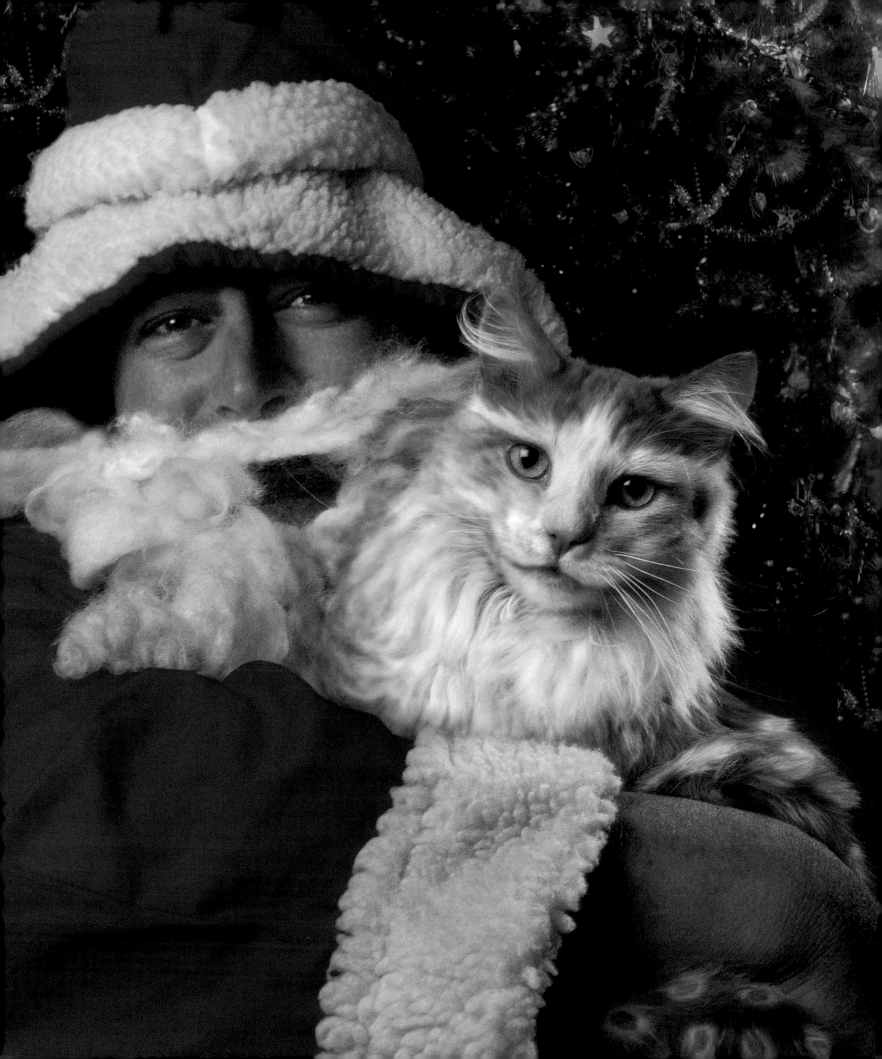

MARGIE GRAY
~ Artist

RETRO-RITUALISM

"Santa's cats provide a wonderful opportunity for all the children who want to give something back to Father Christmas..."

~ Artist

Ever since the success of her first Santa's Cat, Margie Gray – who paints watercolor seascapes most of the year – is run ragged in December doing Santa Paws and Santa Claws for children's Christmas parties all over Vancouver. It began when a boy in her daughter's elementary school contracted leukemia and was not expected to live. The children were all deeply affected by it, especially her daughter who, along with other seven-year-olds, often visited the hospital to read him stories. One story was about Santa's cat and from then on little David had only one wish: to see the cat for real. As he explained, he'd seen Santa plenty of times but nobody had ever seen his cat. So Margie and her daughter painted a red cap and cloak onto a white cat, put it outside his window on Christmas Eve and arranged with a nurse to say she'd heard meowing outside. David pleaded to be carried to the window and was just in time to see Santa's cat staring up at him. He was ecstatic, and from then on his health began to improve.

The next year there just had to be another Santa Paws and all the children brought it presents. It quickly became a tradition, right down to leaving a saucer of milk out for the cat who the children figured had to be the one that came down the chimney with the presents. "Santa's Cat," says Margie, "provides a wonderful opportunity for all the children who want to give something back to Father Christmas but feel their presents could never be enough because he already has all the toys in the world."[1]

LEFT: *Santa Paws,*1998. Vegetable dye on *Jix*, Turkish Van. L. Sims, Burnaby.

"...Margie Gray spurns the role of artist as originator and steps into the realm of artist as myth maker to present us with images that are at once rich in nostalgia and deeply disquieting. By lifting the red and white cloak from the shoulders of none other than jovial old Santa, undoubtedly one of the most repeated images in western culture, and deftly wrapping it around another common commercial image – the body of a cat – she makes us painfully aware of the continuing unhealthy santaization of winter solstice symbolism with its stupefying illusion of male as dominant gift giver."[2]

[1] Margie Gray is currently working on a book about cat painting for children called *The Hair & The Turquoise.*

[2] *Tyndal, P.* Male Neochauvinist Symbolism in Solistian Ritual. *Journal of Wicca Arts & Craft, Vol. XIII, 1999.*

ZENO BARON
~ Artist

POST-MUNCHAUSENISM

"We get upset with the cat painted as death because we don't want to admit that our beloved cats are killers!"

~ Cat's Guardian

Zeno Baron's work conforms to Braque's requirement that art should disturb, to say nothing of making you jump out of your skin. It was once described by a critic as being "...on the teasing edge of macabre with an increasing tendency to fall right off."[1] But Baron refutes such detractors by saying they're "shallow," and "afraid to engage with the inner message." Certainly there is no shortage of cat lovers willing to part with up to $10,000 for what Tom Yates, who commissioned *Bone Voyage*, calls "...Baron's valuable razor-sharp insights into eco-feline dysfunction." By letting his cat, Bruno, wander outside looking like a living skeleton, he claims to have alerted his neighbors to the fact that by keeping unsecured cats they were directly responsible for the cruel destruction of hundreds of songbirds every year.

However, his neighbors claim that the cat's body art was simply tasteless, and had the artist not mailed them all a note revealing the message behind the bones, they'd be none the wiser. Most were distressed by the cat's appearance and several thought Yates probably felt bad about it too and was trying to find some justification. Also, it didn't go unnoticed that his children entered Bruno in a Halloween dress up competition and came away with a hefty first prize. But Yates remains adamant. "We get upset with the cat painted as death," he says, "because we don't want to admit that our beloved cats are killers!"

RIGHT: *Bone Voyage,* 2000. Vegetable dye & neutralized bleach on *Bruno,* tabby & white shorthair moggy. T. Yates, San Francisco.

Writing in the *Journal of Applied Animal Aesthetics,* Andrew Mason remarked that, "Baron's apparent concern with internal structure, as denoted by his recent titles, *Cat Gut Garters* and *Pussy Gore Galore,* in reality signals a desire to go beyond a simply banal imposition of the grotesque and assert a deeper, more involving understanding of the dichotomous position of the domestic cat in the current North American ecological dialectic."[2]

[1] Eliot, J. Anacomically Correct? *Modern Cat Painting, Vol II, 2001.* [2] Mason, A. Internal Politics, The search for a Post-Munchausian Feline Ethic. *Journal of Applied Animal Aesthetics, Vol. VI, 2001.*

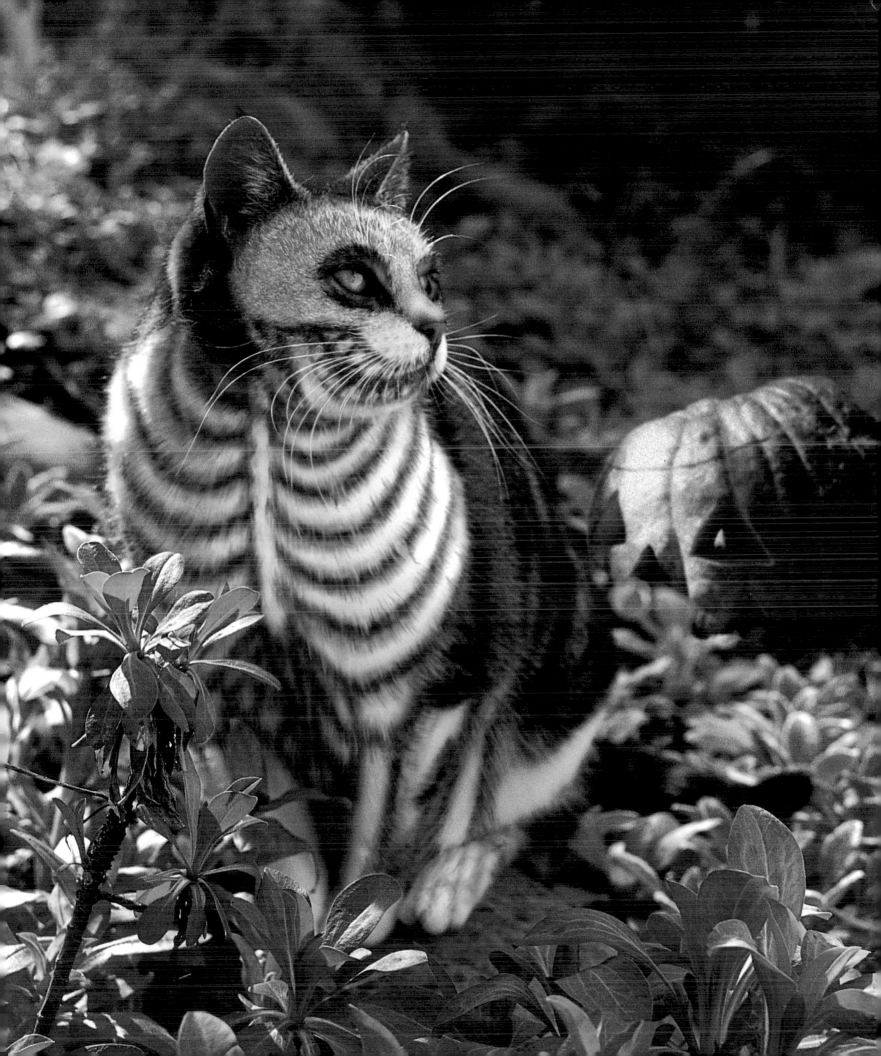

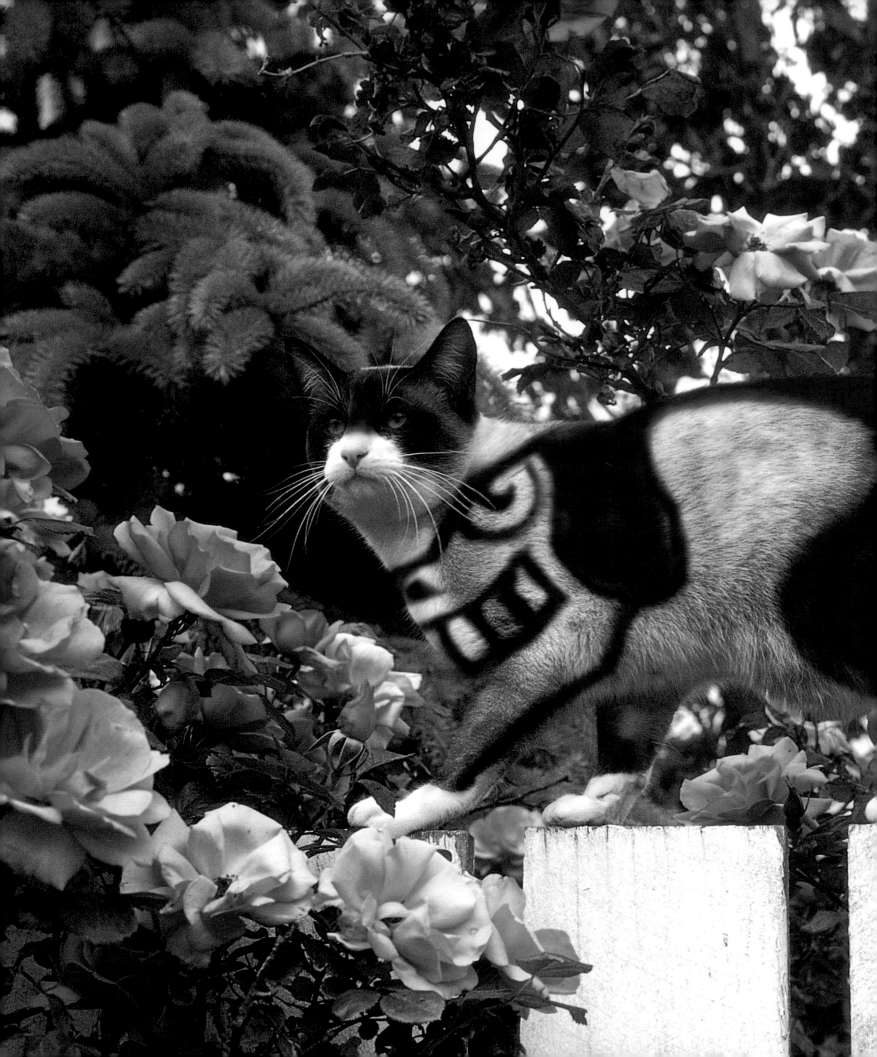

LEFT: *K9 Kitty,* 2001. Vegetable dye on *Mindy,* Siamese Snowshoe Cross. C. Smail, San Francisco.

This $4,000 work by Zeno Baron, commissioned by Celia Smail, was designed to protect her cat, Mindy, from attack by the neighbor's Fox Terrier. It worked so well that the cat was able to stroll boldly into the next door garden in broad daylight (when the design was visible), while the dog cowered in its kennel.

Ms. Smail admitted to some initial qualms about having her cat painted but was assured by the artist that there could be no ethical objections to painting a cat for its own protection. Unfortunately there were. What nobody had considered, until the very distressed neighbor arrived with the gruesome evidence in a plastic bag, was that Mindy was now free to prey on the birds in the next door garden at her leisure. Judging by the quantity of feathers in the bag, she had evidently set about her sport with great enthusiasm. So there was no expensive post-painting restoration work two months later to keep the design alive. Instead, Ms. Smail elected to keep her cat inside till the paint finally moulted away and she is now suing Zeno Baron for unprofessional information.

Ms. Smail said, "I am also thinking of bringing a separate case against Mr. Baron for failing to consider the effect his design would have when my poor cat saw herself in the mirror."

29

IRIS MOYLE
~ Artist

TRANSFIGURATIONALISM

"…Thomas is reminding each and every one of you to think of me as if I were a cat. For I always have time and I will never judge."
~ *Cat's Guardian*

Iris Moyle's religious symbols and scenes have appeared on hundreds of cats all over England, but throughout her career she has only accepted commissions that would provide viewers with a more spiritual understanding of the cat. Her recent refusal to depict a deceased Bishop being transported to heaven on a donkey with his crook —the cat's tail — between his toes, is a case in point. On the other hand, The Very Reverend Bartholomew E. Stoke's black cat, Thomas, painted wearing a matching ecclesiastical collar and cross, is a good example of a work which, in the artists view, upgrades the feline presence. In a sermon to his Oxbury congregation, Dean Stokes explained it like this:

"I wonder how many of you talk to your cats? I know I do, and I'm sure many of you do, too. And I'm also sure there will be those among you who sometimes share your problems with the cat. Just sit with him or her on your lap and find comfort by pouring out your concerns. And we do that, don't we, because our cats listen to us. They're never too busy to hear us out and they never judge or burden us with their problems in return. And that is why our beautiful Thomas is wearing a collar just like mine this Advent. For as we enter the stressful Christmas season and our problems seem to multiply, Thomas is reminding each and every one of you to think of me as if I were a cat. For I always have time and I will never judge."

RIGHT: *Collared,* 2001. Organic peroxide & hair dye on *Thomas*, moggy. Very Rev. B. E. Stoke, Oxbury.

Another work by Moyle, *Temptation, Genesis 2: 17,* 1999, a kinetic pictograph as installation in the nave of St Peter's, Hull, shows insightful use of the feline fur canvas to articulate a meaningful interaction between elements of design. "Two large red apples, one on each flank, represent the fruit of the Tree of Knowledge, while the cat's lithe serpentine tail, dyed bright green, flicks seductively over each fruit, at once caressing and offering. The overall effect conveys a clear message of eternal damnation if the fruit were to be penetrated by the tail."[1]

[1] *Murdoch, Father T.* A Woman Inspired. Celebrating Iris Moyle's Ten Year Feline Ministry. *Spiritual Life Today, Vol. VI, 2002.*

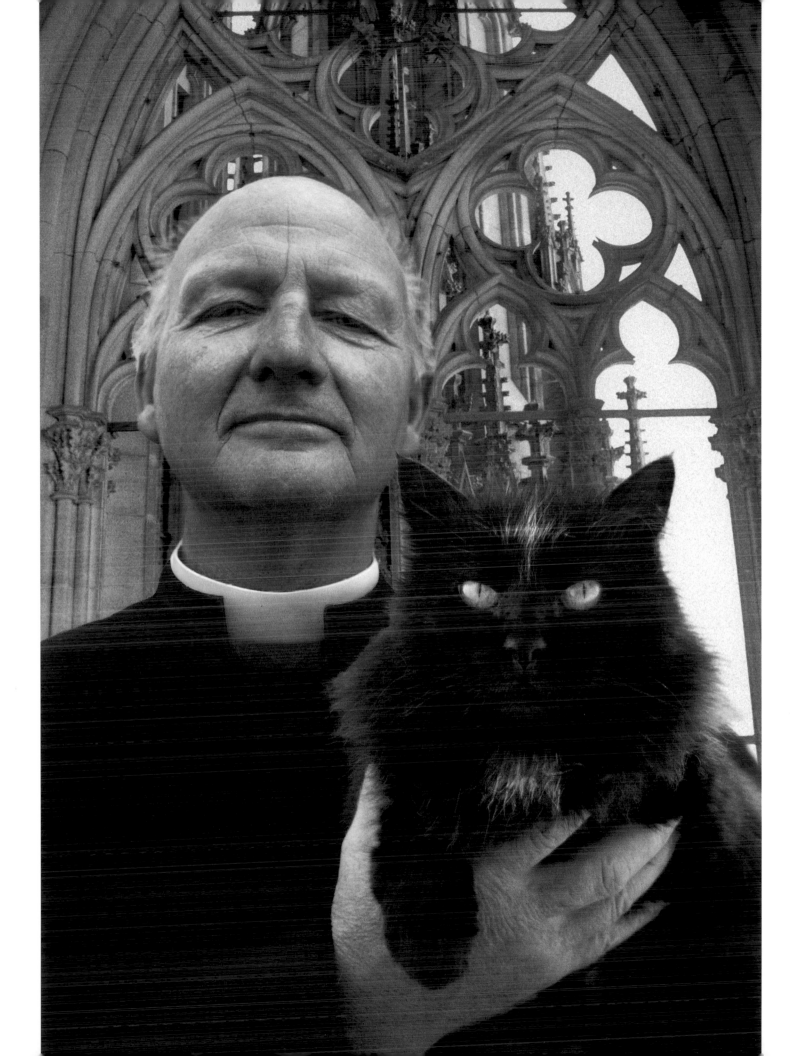

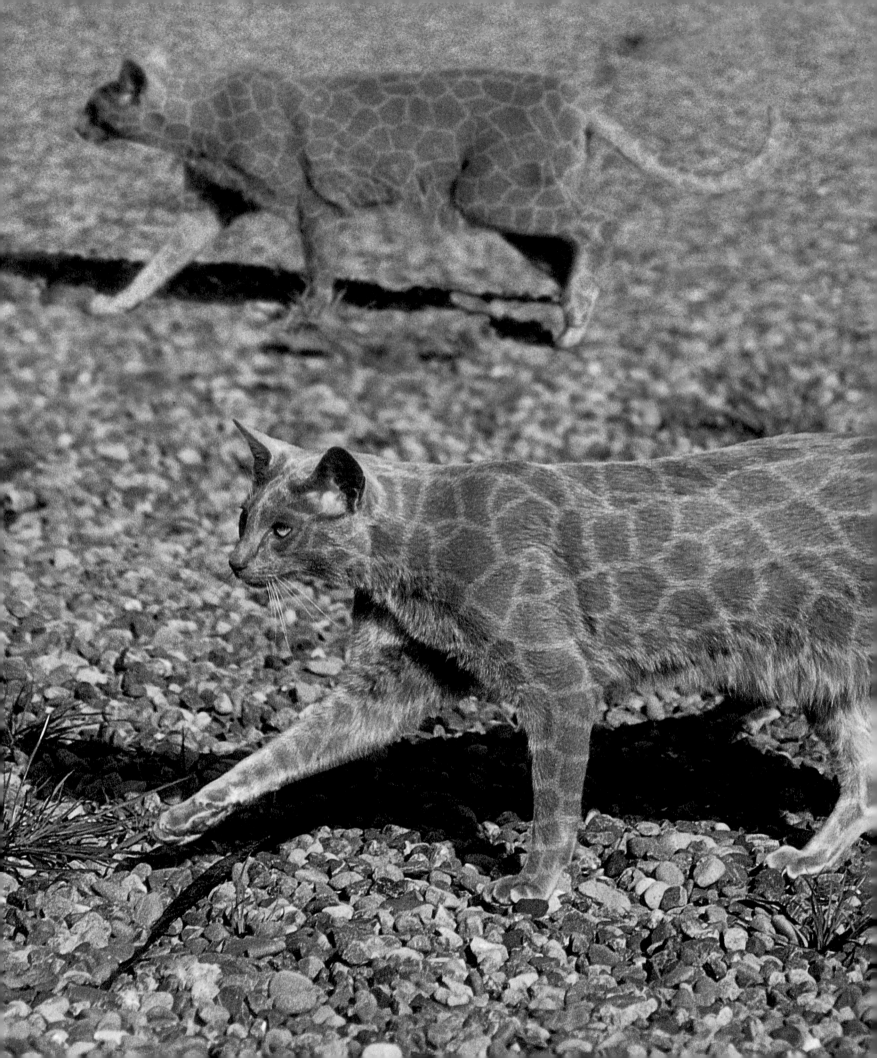

BRUCE TAYLOR
~ *Artist*

Re-Environmentalism

"Imagine if we bred cats to eat leaves and they started traveling in big herds like giraffes." ~ Artist & Cats' Guardian

Bruce Taylor breeds Orientals specially for painting and was one of the first to use multiple cats to create a moving picture. By imposing the image of a species, or part of a species, on to another species so that it can be seen moving differently in a new environment, he has been able to provide powerful insights into our understanding of the territorial prerogative. "What if fish came and plundered our environment as we have plundered theirs?" he asks pointedly as his furry Neon Tetras flash this way and that among the trees. "Or imagine if we bred cats to eat leaves and they started traveling in big herds like giraffes."

Taylor's more recent work,[1] which explores the damaging effect of warfare on cats, utilizes the new fluron dyes on much larger feline groups. In *Tracer Shells*, 2002, forty-six cats with bright white fluron-tipped tails, leap over upturned chairs and tables (depicting social chaos) in response to rapid bursts of recorded machine-gun fire. In the darkened space the effect is startling, the message disturbing, and the method ethically challenging.

Left: *Horizontal Giraffes*, 2001. Non-toxic dye on *Safari & Sneak*, Havana Orientals. B. Taylor, Flint.

Cats adopt giraffe patterns and travel together in silent herds to commit their herbivorous carnage.

Overleaf: *H² No Fish*, 2001. Non-toxic fluron dye on *Flick, Slim, Slipper & Shoo*, Oriental Blues. B. Taylor, Flint.

Black light is used to highlight these shimmering schools of re-environmentalized Neon Tetras.

[1] Taylor's War Series is reminiscent of Sandy Skogland's *Radio Active Cats, 1980*, in which twenty bright green cats interact with two humans and a fridge to suggest the use of feline flesh as a post-holocaust food source.

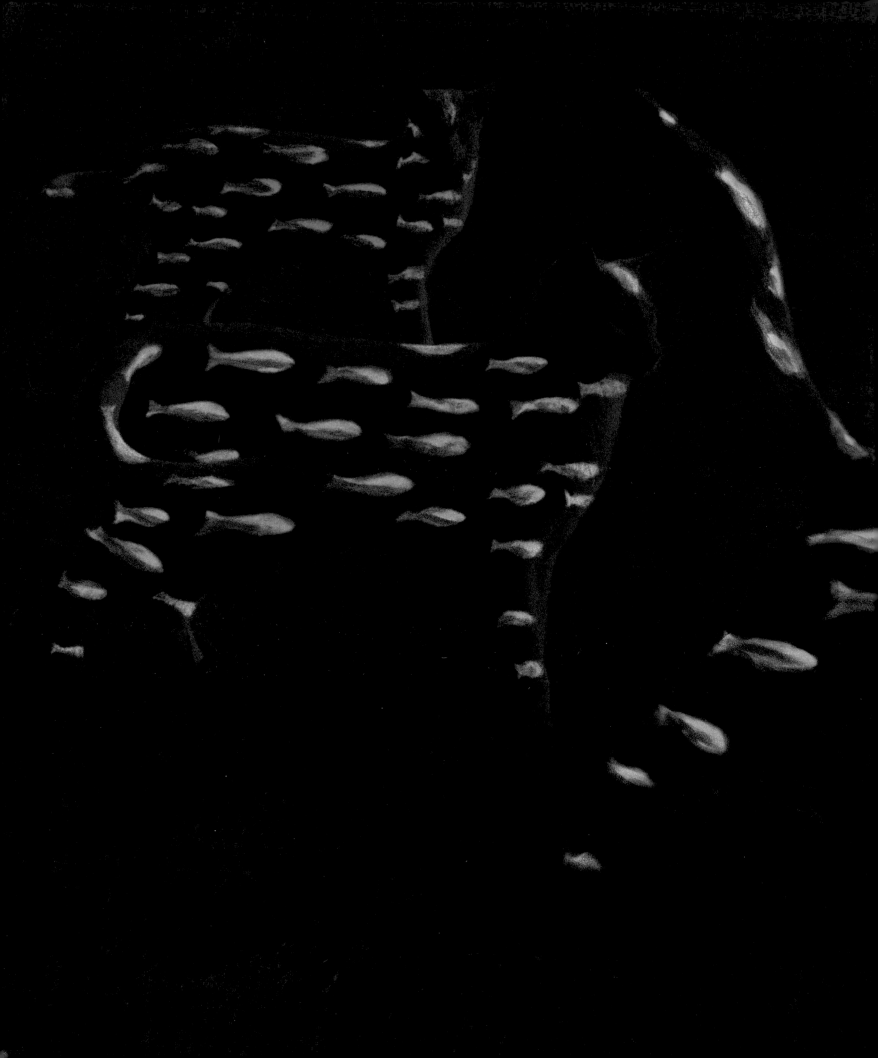

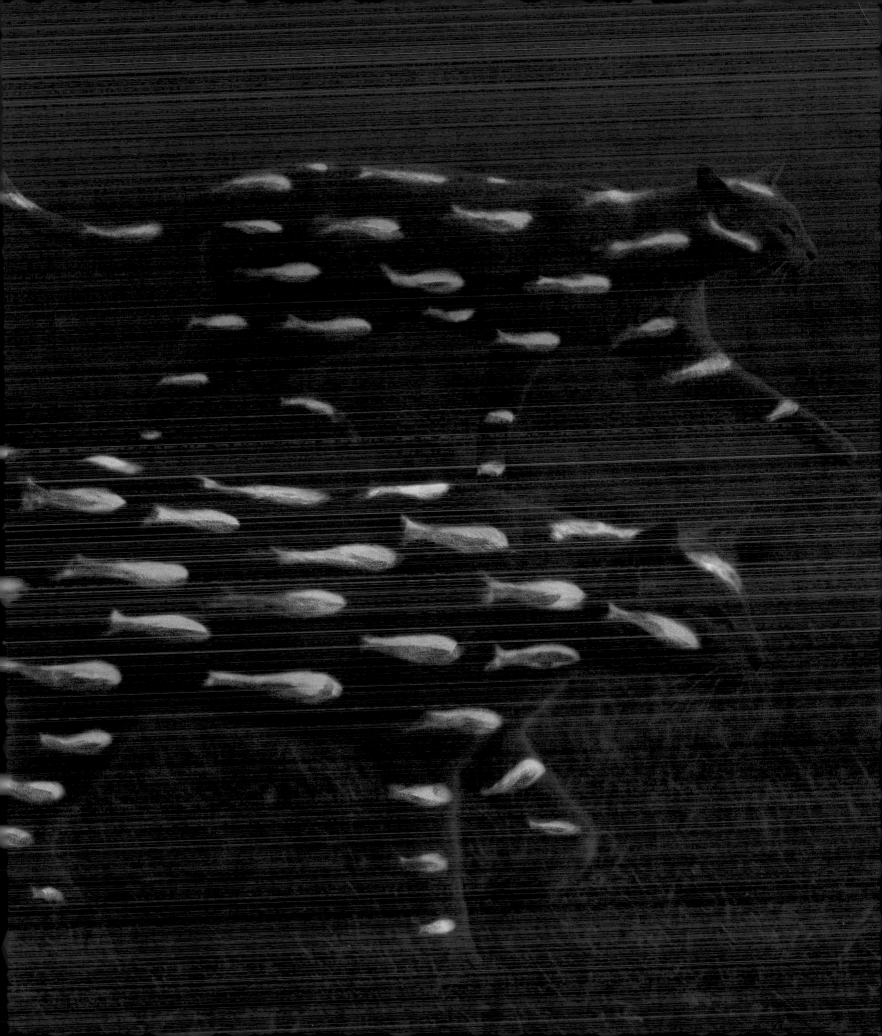

MATT GAURI
~ *Artist*

TRANSMOGGIFICATIONISM

"There was no way we wanted our lovely white kitty turned into a pink pig. We hate pigs!" ~ *Cat's Guardians*

Matt Gauri's dramatic makeovers are designed to confront us with our own prejudices. By transforming the lovable cat into a less appealing animal, he hopes to instantly change the way we feel about it, which he claims will directly affect the way we treat it. "Apply this propensity of ours for stereotyping every known species," says Gauri, "and you have a recipe for environmental disaster. That's why my works are important."

Until recently Gauri was working for a pet motel in Los Angeles that offers a complete grooming and painting service, but a mix-up over identical white cats and the ensuing argument, rendered his position there untenable. Instead of being delighted that their cat now looked like a pig when they returned from their vacation in Florida, Mr. and Mrs. Porter, were in fact appalled. "There was no way we wanted our lovely white kitty turned into a pink pig," said Mrs. Porter. "We hate pigs! And then, instead of apologizing for painting the wrong cat and maybe offering some kind of compensation, this so-called artist starts going on about how our attitude proves his point, and shows the power of his art. As my husband said to him, we know pigs are okay, we just don't like them. I mean, horses don't like pigs either, so what's the big deal?"

Matt Gauri deeply regrets the incident and is disappointed that *Pigmylion* was never exhibited. "Okay I painted the wrong cat," he admits, "and I guess pigs aren't that popular. But I can't help thinking it had to do with Mr. Porter being an ex-cop."

LEFT: *Pigmylion*, 2001. Vegetable dye on *Shadrack*, white moggy. C. & O. Porter, Los Angles.

"Matt Gauri's *Pigmylion*, 2001, (literally: asking to have the 'pig' put into your 'lion'), is only available to us as a two-dimensional photographic image. This limits our appreciation of the work when compared to others in his *Swine Series*, which benefit by being viewed in the flesh. 'A pink soft-footed furry pig / A feline-smooth non-grunty jig,'[1] is at once entrancing and deeply thought-provoking. But even without the stimulation of live performance, *Pigmylion* is able to demonstrate the power of biological triggers to shape our thoughts and concomitant actions."[2]

[1] *Khan, O.* The Rubaiyat of a Painted Cat. [2] *Robertshaw, M.* Pigs Can Fly When Cats Do Dye, Establishing a Feline-Swine Dynamic in the Context of American Transmoggificationism. *Cat Art Today, Vol. IV, 2002.*

After his fruit bat series, Matt Gauri is best known for his birds, especially owls and turkeys, which, along with his pigs and pea green boats, he developed for the annual Edward Lear celebrations in Cannes.

All his owls are designed to be seen with the cat in an upright sitting position. Gauri explains that this is how we're used to seeing owls, but when the cat sits in the crouched position or walks, the design still has to work on another level because it won't be read as an owl anymore. The artist has overcome this problem by ensuring that the parallel wing lines are finely drawn (he uses stencils) and sweep up in a graceful arc from the base of the tail, along the line of the dorsal muscle, and join with the trapezius at the shoulder. Provided the design flows naturally over the body in the direction of the muscle fibers, it will always be unified and the cat's natural elegance enhanced, no matter what position it takes up or how it moves.

The price Gauri receives for a work is largely dependent on the time it takes. Something fairly straightforward such as a pig on a white cat, costs around $5,000. But if Gauri is employed to do the pre-paint petting exercises as well, it can add another $2,000 to the bill. More complex designs like owls come in at $7,000 and turkeys can set you back a whopping $12,000. His most expensive work to date was $15,000 for a cat painted as a pig in a tuxedo to represent a bride's ex-husband at her Beverly Hills wedding.

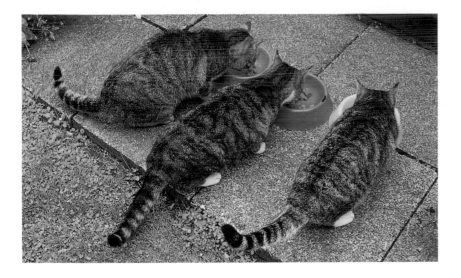

LILLY SPENCER
~ Facilitator

COMPLEMENTARY AFFIRMATIONISM

"People who come to the shelter respond very warmly to painted cats and they're a lot more likely to be taken home than unpainted ones." *~ Artist*

In 1999, Lilly Spencer, a fine arts student at U.C.L.A., was sent to a new private therapy center in Spring Valley near San Diego that uses cats to help young women recover from traumatic experiences. Three years later she's still there, but now as a member of the staff in her new capacity as artistic director of the Feline Affirmation Program. The center operates on the premise that people recover more quickly from emotional stress if they can receive and give plenty of unconditional love. Naturally, help from human counselors is paramount but cats are very good at both giving and receiving affection, and when a strong human-feline attachment is forged, it can assist in the recovery process. Lilly's job is to build that attachment and she does it by encouraging her charges to become totally involved with their cats and with the painting of them.

Veronica (left), came to Spring Valley following the death of her parents in a car accident. She lost four fingers in the same accident and had some anger to work through before getting to know the center's more than twenty very relaxed and out-going feline helpers. When she did meet them, she quickly selected Timbo, a big, loveable, no-nonsense tabby to be her cat partner and settled into regular sessions with him and Lilly every morning. "There's a whole lot of crying and holding and stroking at first," Lilly explains, "but they come through that and then the cat painting is there as something positive to move on with."

ABOVE: When these three cats (from left, Timbo, Viks and Sam) were painted with different colored stripes at the therapy center, it was noticed that they almost always chose food bowls of a color that matched their own fur. This raises the possibility that cats may be somehow aware of their new colors and change their behavior accordingly. As yet there is little supporting scientific evidence but a French study, sponsored by a pet food company, has shown that cats dyed bright red prefer red meat and those dyed blue or green prefer chicken.[1]

LEFT: *Salad Days,* 2000. Non-toxic, semi-permanent dye on *Timbo,* tabby moggy. C.A.A.H. Center, Spring Valley, San Diego.

[1]Research project titled: Les chats rouges aiment la viande rouge et les chats bleus le poulet. Undertaken by *Dr. Patrick Rois,* Directeur du centre de recherche sur les préférences des animaux, Paris, 2001.

ABOVE: It is important that any design on the face or head is made slightly darker than the rest of the work. This is because cats wash their faces and heads with the back of their front paws and tend to rub off more dye from this area than other areas washed by just licking. Keeping the washed area darker ensures that the overall continuity of the work is not compromised by a washed-out area. Note the dye on Shaman's front paw (right) from washing his face and head.

RIGHT: *My Psychedelic Skat,* 2001. Non-toxic dye on *Shaman,* ginger longhair moggy. C.A.A.H. Center, Spring Valley, San Diego.

"Painting a cat isn't easy," says Lilly. "It calls for a great deal of pre-paint petting preparation with a dry brush to get the cat comfortable with the process and to find out exactly how it will react. Artists have to be very alert and watchful all the time, but it's this concentration that enables these young women to focus on something outside of themselves and thus begin to heal. Their first designs are very simple and straightforward. Maybe just a little heart on the cat's head or perhaps a few rings around its tail using semi-permanent dyes that can be easily removed with an organic thinning agent. They then move on to complementary designs that affirm the relationship, such as painting the cat's socks the same color as their own or perhaps giving it matching glasses or jewelry."

Veronica completed her first-stage affirmation work with another group who dyed their own hair to match the vivid stripes they'd decorated their cat partners with. There were many more painting sessions, but after six weeks it was finally time to leave and, as is sometimes the case when a particularly strong attachment is created, Veronica was allowed to take Timbo with her. She now lives and works in Santa Rosa and in the weekends lends a hand at a no-kill animal shelter, painting the less attractive cats to help them be chosen for adoption. "People who come to the shelter," says Veronica, "respond very warmly to painted cats and they're a lot more likely to be taken home than unpainted ones."

When Sara arrived at the center with her long ginger tresses and met the similarly adorned Shaman, the stage was set for fireworks. They bonded instantly and it wasn't long before he'd become the skunk she'd always wanted – thankfully without the smell. "Shaman just let it happen," exclaimed Sara. "He let himself become my fantasy. It's like he's a really wonderful friend, and this is his gift to me."

While these overly effusive feelings are normal in early-stage recovery, they nevertheless raise questions about our right to treat cats as human substitutes – objects that are merely reflections or projections of ourselves. Dr Stephen Smith, who is in charge of the center's feline program, says he can't honestly say that the cats' needs and rights are as important as ours in practice, though he feels they certainly are in theory. "I think you have to be realistic," he says. "We use animals to heal ourselves, just as we use them to feed, protect and transport us. In return we give them food, shelter and love. It's undeniable that cats at this center are treated like human substitutes, but we don't think it harms them and we're very careful that our patients don't physically maltreat them." [1]

[1] One animal liberation group disagrees and has countered with a poster showing a heavily made-up woman with a painted cat on her lap. The caption reads: "Just because your face needs painting..."

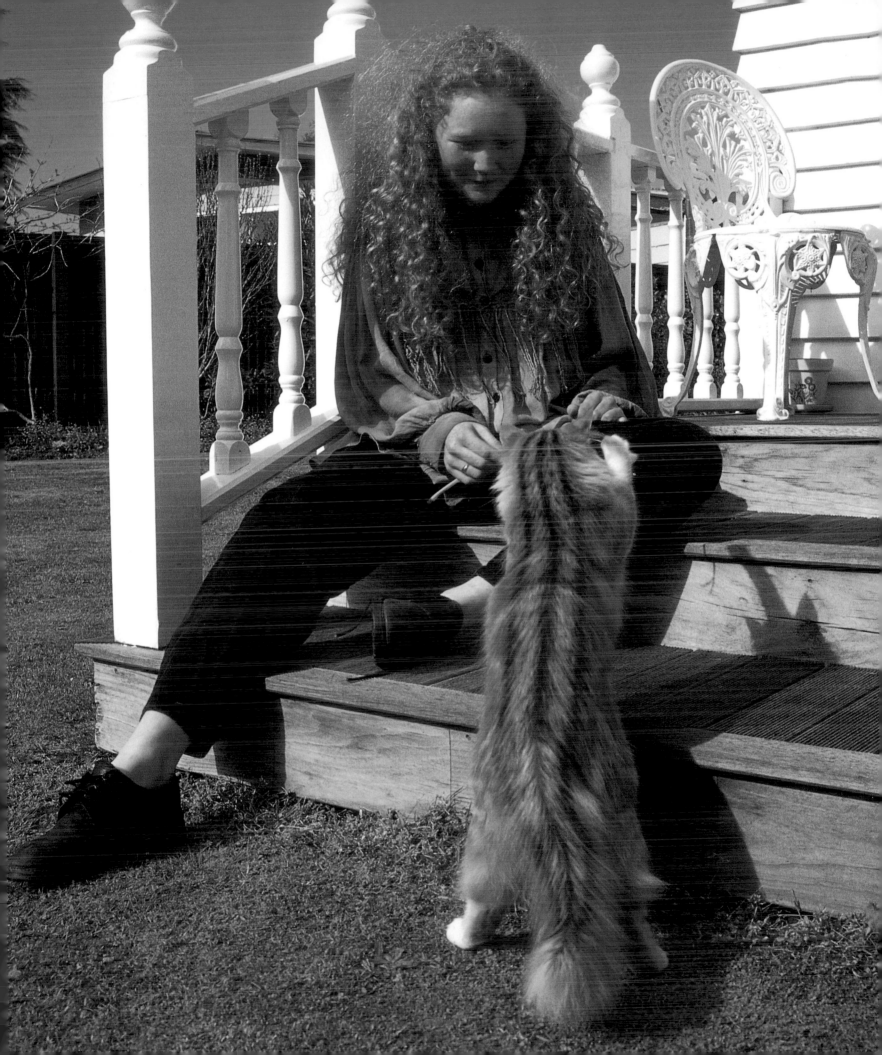

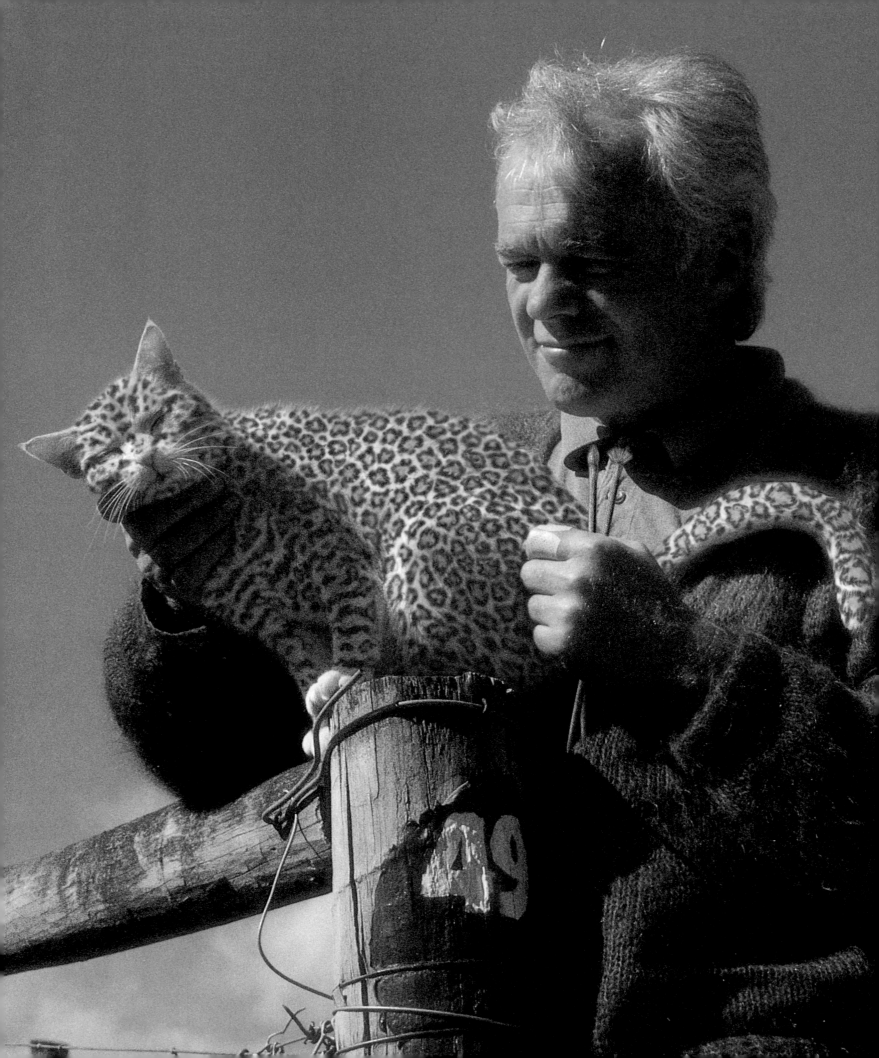

CHANTAL CHARLIER
~ *Artist*

Nouveau Classicism

"She was such an elegant cat, so fine and self-assured, and such a bitch to work with!" ~ *Artist*

Each time Chantal Charlier curls up by the fire with Henri, her chic Lavender Ocicat, another cat smiles down at her from its silver frame on the mantelpiece above. Celeste is bright turquoise with tiny flecks of red and gold that stream along her back and cascade in sparkling rivulets down her soft velutinious sides. "Not the best of my cat paintings," she observes critically, "but it's the one I did for Vidal, the one that got me started. She was such an elegant cat, so fine and self-assured, and such a bitch to work with!"

But as a costume designer for a theater company in Paris, Charlier is well used to handling big egos and brings to the feline canvas her considerable skill as a fabric painter and her knowledge of how to enhance an actor's physical and expressive ability through choice of pattern and color. In spite of this, her work has never received the critical acclaim she feels it deserves. Certainly Charlier's classical patterns may seem exclusively intent on delivering the definitive, and occasionally vacuous fashion statement, but it would be wrong to give the impression that she is incapable of nuanced reflection. Clearly her work is commercially successful, commanding up to $11,000 for each painting, and this in itself may account for the degree of critical hauteur it has received in recent years. Whatever the reason, her beautiful designs have delighted cat lovers all over Paris and will no doubt continue to do so – with or without the approval of the critics.

LEFT: *Leopardo,* 2000. Vegetable dye on *Fleur,* white moggy. A. Bat, Paris.

While popular with the public at its first showing in Paris, *Leopardo* was clawed by the critics:
"...we are informed in the catalog by Ms. Charlier that her work contains a powerful conservation message. This, she tells us, has been achieved by shaping the leopard spots to represent endangered species that are killed for their fur by the apparel industry. A closer inspection, however, reveals only the vague form of a frog, a goat and a seal, as well as a telephone, a hand grenade and a snail. Perhaps we should therefore expect insights into the slow pace of detente in the Middle East?... If this artist wishes to gain the conceptual high ground... she will need a more radical change of spots." [1]

[1] *Hindry, A.* When Leopards Change Their Spots. *L'Art Press, Félin Spécial No.987. Paris, 2001. (*In order to score a cheap point, this reviewer has failed to mention the clearly drawn Pygmy Rabbits on the cat's tail).

RIGHT: *Madame Souffle,* 2000.
Vegetable dye on *Coco,* Birman.
Dr. P. S. Ramette, Paris.

Many of Chantal Charlier's feline
designs involve subtly blending the cat
with its surroundings. She does this in
order to engender the feeling, in the
mind of the viewer, that the cat is
integral to its living space and shares a
spiritual presence with other beings
who reside there. Of course this is
never achieved by simply painting the
cat to match the decor. Its successful
execution requires a high degree of
aesthetic sensitivity and involves not
only an intimate understanding of
how each cat likes to "be" in the
home, but also an in-depth knowl-
edge of Feline Feng Shui.

 In order to enhance Coco's
already serene sense of belonging,
Charlier chose resonating colors at
low intensity levels from the crystal
spectrum and applied them in over-
lapping leaf forms to shroud the cat in
an ethereal, mother-of-pearl-like haze.
According to Coco's guardian, it was
as though the cat's presence was fil-
tered. It seemed vaporous and lighter
than air – apart from and yet a part
of the furniture.

LEFT & RIGHT: *Fleurs jaunes sur fond bleu*. 2000. Organic peroxide & vegetable dye on *Tiggarette*, tabby & white moggy. R. A. Brignone, Paris.

Hand-painting floral fabrics takes Chantal Charlier a fraction of the time it takes to complete Tiggarette's vibrant yellow blooms. This is because the latter images, so rich in color, have to be meticulously built up layer by layer. It may be simpler now with the new vacuum stencil brushes that can be adjusted to suck up exactly the right amount of fur, but it's still very time-consuming, especially when the cat is young and decides it needs to check just one more time that the brush is not related to a mouse. "It's fortunate," says Charlier, "that cats sleep for up to eighteen hours a day."

Like other cat artists, Charlier finds a good deal of her time is taken up with restoration work. This may be undertaken to extend the overall life of a cat painting beyond the normal two months, or to repair an area that has become too light from over-licking or rubbing. Restoration work calls for a great deal of skill to accurately match the surrounding color and in some cases can cost as much as the original work.

BRIDGET BRÜCKNER
~ Artist

TRANS-EXHIBITIONISM

"First I paint the cats to show their potential to the men and then I paint the men also." ~ Artist

Bridget Brückner, painter, choreographer, violinist, and veterinarian who hails from Bremen, not only paints cats – she paints their guardians as well. Describing herself as an "out there" person who likes to "show herself," she feels people want to be more explorative and expansive but lack the confidence to experiment with the image they project. Her art on cats is designed to do just that. She works mainly with the men who bring their feline companions to her clinic, as she thinks men are more constrained than women, especially in Germany. "First I paint the cats to show their potential to the men and then I paint the men also. And when the men are feeling better they are thanking the cat, yes?"

What this feisty fräulein aims to give these men is a chance to reinvent themselves by reinventing their cats. The inevitable result she claims, is a happier man with a happier, better understood cat. Once the man sees how different the painted cat looks and realizes how differently he feels about it, he becomes excited about trying it himself. Painted moustaches are her favorite because they really enhance the mouth and make a man look so distinctive, quite apart from the fact that real ones hold the all important bonding pheremones which are exchanged in kissing. But she employs a full makeup kit and tries out rings, hats, wigs, glasses – anything that helps to present a new image. Then, claims Brückner, when the man sees himself in the mirror with his matching cat, not only does he see that he's projecting in a new way, but he knows his cat is supporting him.

LEFT: *Katzenschnurrbart,* 2000. Non-toxic, semi-permanent dye on *Tosca*, Persian. E. Pracht, Bremen.

Brückner's art is seldom exhibited but it did receive critical attention at an exhibition which included C Type prints of her *New Man,* 2001, series in Bremen. "A naked, large-bellied man is painted onto the side of a cat. He is portrayed in the supine position, supported above the ground by his thin outstretched arms and legs which are painted on to the cat's legs. Since the man faces the rear of the cat, the cat's purple-colored tail becomes genitally implicated in what appears to be a quite uncircumscribed discussion of male assertiveness in the context of post-reunification Germany." [1]

[1] *Stemp, M.* Bridget Brückner and Der neue Mann series, 2001. Feline Phallic Imagery and the Trans-Exhibitionist Ethic in Post-reunification Germany, *Exhibition Catalog, 2001, Villa Ikon, Bremen.* [2] *Ibid.*

LEFT: *Der Hanswurst,* 2000. Vegetable dye on *Max*, ginger tabby (polydactyl) moggy. L. Fischer, Oldenburg.

Max's transformation into a clown or *Hanswurst,* is one of Brückner's few exhibited works and undoubtedly one of the most controversial. Literally translated, "hanswurst" means hand-sausage – a term applied to an object of amusement. However, despite the obvious high standard of the work, its name, plus the explicit nature of the installation, created a wave of public disapproval when Max appeared in a Bremen gallery playing on a carpet littered with electric dildos. The media savaged the work as degrading to cats while the critics loved everything about it. Not only did they see it as a refreshing departure from Thomas Grünfeld's stuffed, and grotesquely reconstructed, "animals," but also found it a convincing attempt to pass critical judgement on contemporary sexual mores. Writing in the exhibition catalog, Michelle Stemp wrote, "By juxtaposing disparate realities, Brückner rams together the natural and the artificial, the innocent and the profane, to create a message that continues to reverberate long after we have left the gallery. Where today can one find a more vivid, more piteous reminder of the continual failure of male self-control than by observing this clown as he ineffectively stalks, pounces on, wrestles, tosses, bites and sometimes gnaws, these pathetic pink vermin that vibrate themselves mindlessly around the room?" [2]

EDWARD HARPER
~ Artist

ECO-INTEGRATIONISM

"My work on camouflaging cats is not designed to turn them into attack animals. It is undertaken solely to prevent them from being attacked by dogs." ~ Artist

Before his works became embroiled in controversy and he was forced to resign from A.E.T.A.,[1] Edward Harper was one of the most popular and respected cat artists in Britain. His early paintings were lauded for the way they enhanced cats' natural markings and later, when he experimented with bold bird-scaring designs, he was showered with praise by guilt-ridden ailurophiles everywhere. But it was his camouflage works that landed him in trouble, though at first the notion that they would render the cat less vulnerable to canine attack found universal favor.

In November 2001, F.L.A.P.,[2] an animal liberation group based in Liverpool, publicly accused him of accepting a research grant from the British Defense Council to study improved methods of feline cryptic coloration. They claimed that in reality he was working on ways of camouflaging cats so they could pass human detection while carrying listening devices or biological contaminants. Harper never denied receiving the grant but issued a statement which said in part: "My work on camouflaging cats is not designed to turn them into attack animals. It is undertaken solely to prevent them from being attacked by dogs." However, F.L.A.P. argued that if this were true, then there would be no need for his designs to be colored because dogs, unlike humans, are color-blind. Harper had no good answer to this and following a hearing by the A.E.T.A. ethics committee, he was asked to resign.

RIGHT: *Safe As Mouses,* 2000. Vegetable dye on *Pixel,* brown & white Longhaired Tabby. P. Smewin, Birmingham.

When Pixel appeared in his beautifully airbrushed cloak of muted greens and browns, the critics were florid in their acclaim. Susan Prior, wrote in the Birmingham Globe, "We see and don't see the feline subject of this verdurous installation as he sleeps the sleep of arboreal concealment, safe in the knowledge that he may remain forever unaware of his important corporeal involvement in the wider ecological debate."[3]

[1] A.E.T.A. Artists for the Ethical Treatment of Animals. [2] F.L.A.P. Free Laboratory Animals Permanently.
[3] *Prior, S.* Harper's Bizarre Cats. *Birmingham Globe, 2000.*

54

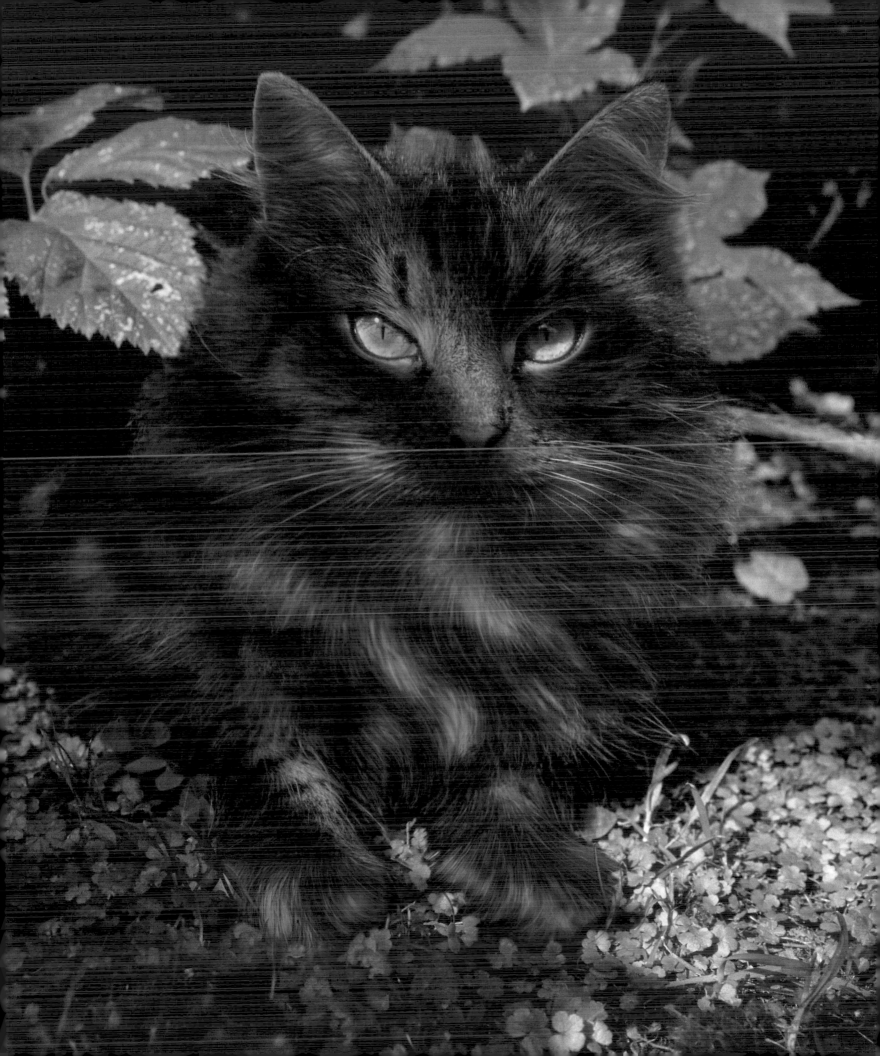

LEFT: *Where Have All The Birdies Gone,* 2000. Vegetable dye on *Sadie,* blue-cream tortie moggy. W. Baird, Birmingham.

Edward Harper pioneered the painting of large, brightly-colored eyes onto cats' backs in order to scare birds. He discovered that a combination of red and yellow worked best, followed by blue and green. He also found that effective designs didn't need to be aesthetically unpleasing and could be part of a larger overall design.

Harper's own small study of painted cats compared to unpainted cats in a Birmingham suburb, showed that those painted with eye designs brought in 80% less bird remains as part of their prey presentation than unpainted ones, while the number of rodents presented remained the same for both groups. Cats painted with eyes are now being successfully used to deter birds in vineyards, orchards, market gardens, and in one case near an airport runway.

The effectiveness of Harper's controversial camouflage designs is well illustrated in this photograph. Can you spot the other cat concealed by its herbaceous design?

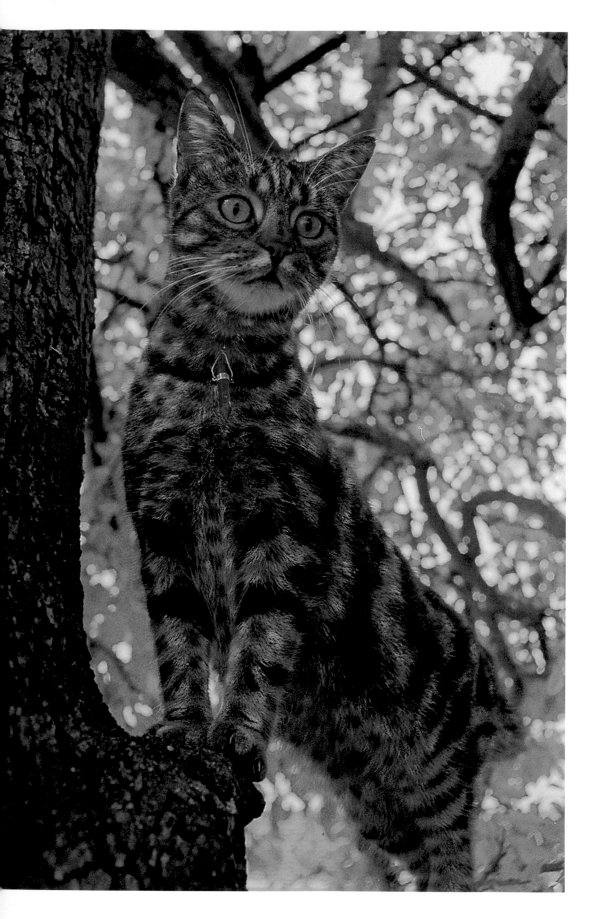

LEFT & RIGHT: *Bird,* 1999. Neutralized peroxide & vegetable dye on *Snaggle*, tabby moggy. A. Wilkinson, Birmingham.

By repeating design motifs from the cat's own markings, and changing their color before integrating them back into the overall pattern, Edward Harper is able to create a cat with all the allure of a tropical bird.

Several cat artists maintain that cats can become aware of their new markings and this awareness may sometimes result in minor behavioral changes. As an example, they point to the fact that some cats painted to resemble fish will spend more time near water and those resembling birds often climb more trees. Harper doubts these claims, but does think it's possible a new fur pattern could influence the cat's morphogenic field.

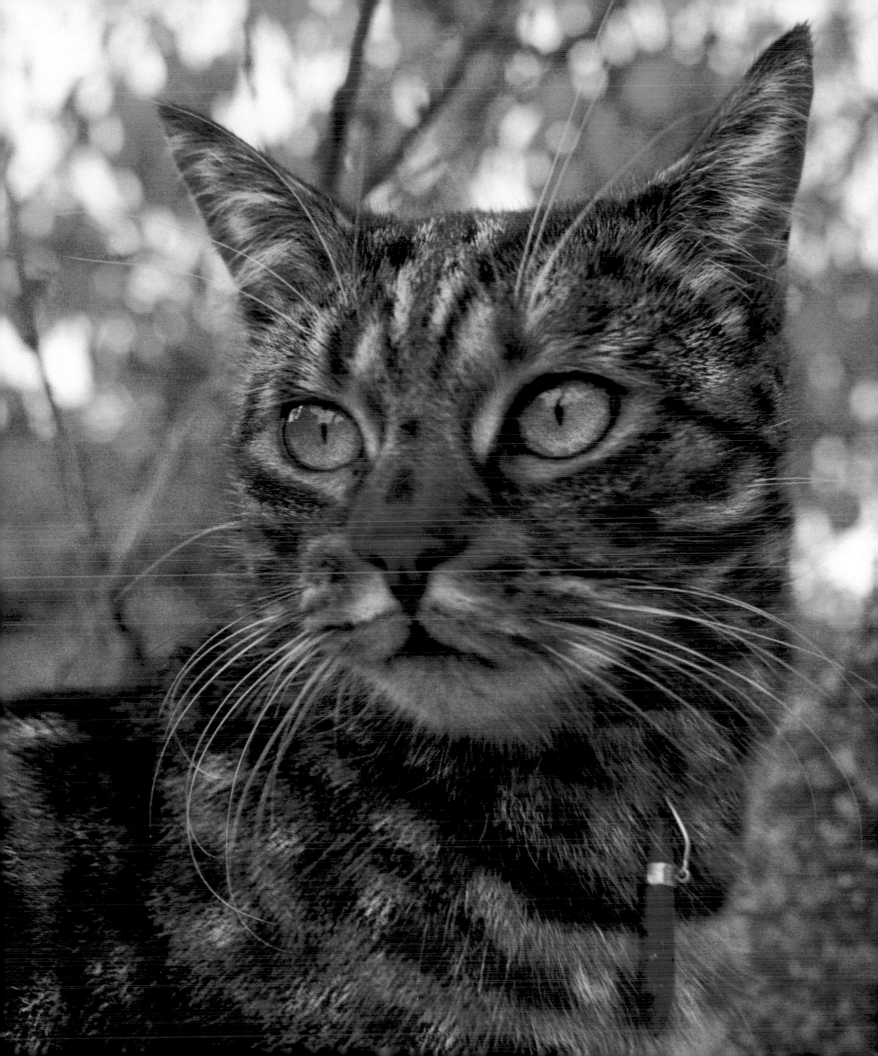

FRED WEIMAN
~ Artist

ANAMORPHIC HYBRIDISM

"You really have to see it with the cat walking because as the cat moves forward the elephant hobbles backwards..." *~ Artist*

Anamorphic designs, which can only be understood if viewed from one angle, are used in nearly a quarter of all cat paintings. For some time these works have not been as highly regarded as all over designs, but recent experiments with multiple anamorphic imagery by young artists like Fred Weiman, may encourage other painters to reconsider this form. His simple cloissonist style fits well with the multi-image concept, and planned works, such as *The Problem Facing Cats*, in which four different views of the cat present as many hybrids,[1] could see anamorphism return to center stage.

Of course complex works like this will always be hard-pressed to convey a clear message, unlike single-image pieces such as *Elephant Backing Out*, 2001, (right) which is rich with embedded meaning. "You really have to see it with the cat walking," explains Weiman, "because as the cat moves forward the elephant hobbles backwards and that gives a very clear conservation message. All this time the cat's been doing just fine living in our homes while the elephant, which is on the brink of extinction in some places, is doing this big backwards shuffle, and we need to think about that when we go to the supermarket to buy our cat food."

RIGHT: *Elephant Backing Out,* 2001. Neutralized peroxide on *Casper,* tabby moggy. K. Brookes, Seattle.

[1]From front-on: a two-faced clown representing animal liberation groups, From above: a crocodile for pet food companies, from below: a tortoise for S.P.C.A. inaction, and from behind: an ostrich for public denial.

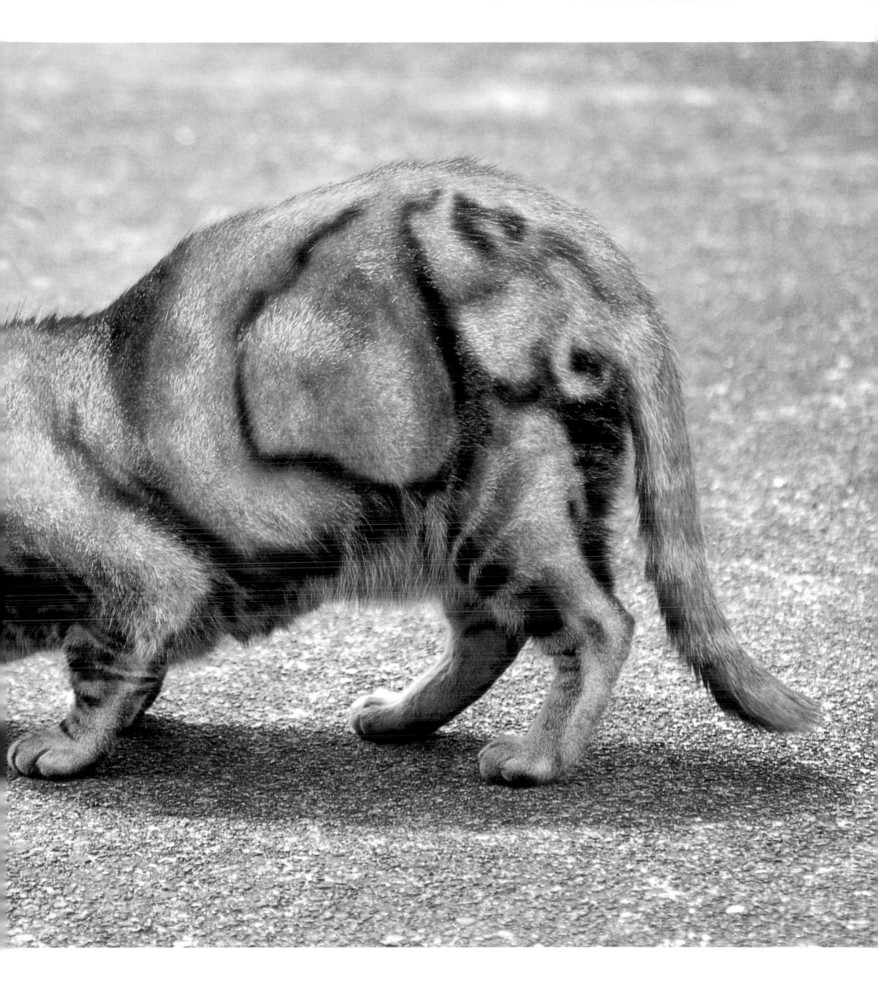

LEFT & RIGHT: *Fish Fishing For Fish. Cat Hunting For Cats?* 2001. Vegetable dye on *Fairy*, Rex. P. Banks, Seattle.

Fred Weiman doesn't much care for reviews of his work. At best he thinks they miss the point and at worst they ensure nobody knows what the point is. There was one review of his "Fish" by Joy Hill in the Seattle Courier that he's particularly fond of quoting:

"This work is perhaps best understood in terms of Wittgenstein's concept of 'seeing as,' for unlike other *peintures chat*, Weiman's art is not based on any complacent liberalization that seeks to conceal the hunter-prey dichotomy. What he offers us instead is an ever-deepening visual contemplation of the nature of feline and trans-feline identity – a living installation that simultaneously merges the feline with the piscine, at once redefining and blurring the relationship between fur and scale, fin and tail, in order to create a shared intent that transubstantiates the species and repositions the notion of symbiosis at the core of life. Now, set apart in clinical isolation, we are enabled to discover the decontextualized narrative of the work, and in so doing, gain insight by questioning our own uncertain responses."

Weiman detests long-winded reviews like this and is at pains to point out that the simple ecological message about the domestic cat's artificial position in the food chain, which he insists is clearly spelled out in the title, is not even addressed. "If the importance of an artwork is based on its ability to engage the greatest number of people," he storms, "then wordy reviews ensure its unimportance by disengaging everybody."

SAM CAWKER
~ Artist

SEMIOTIC ANTHROPOMORPHISM

"Of course a cat can't point to a picture of a tattoo on the wall and say, 'I'll have that one.'" *~ Artist*

Jim Lynch is a self-confessed Ford fanatic who likes to take his '51 Custom with its 460 Lincoln V8 to shows all over Texas. The car has won three first prizes, two second prizes and plenty of minor trophies, but he freely admits that when Flash comes along for the ride with a new set of tats, his cat always gets more strokes than the car. A few days before he hits the road, Jim drops Flash off in Texas City for a paint job with his brother-in-law, Sam Cawker, who runs a tattooing outfit. A reversed-out face design can take several sessions, depending on how Flash feels and what he wants. "Of course a cat can't point to a picture of a tattoo on the wall and say, 'I'll have that one,'" says Sam, "but when you're actually painting it, the cat can certainly let you know if you're on the right track." He claims all cats have natural pathways in their facial fur that relate to their scent glands and provided the design follows these, there's never a problem.

"What can be a problem," says Flash's guardian, Jim, "is having to continually explain to folks that the cat's tattoos are not permanent like mine. Not that Flash would know or care one way or the other. What's important for him is the way people respond to him, and at shows they love his big name[1] and his tats. Of course a lot of them have tats too so there are plenty of suggestions about other designs that might look good on him —'specially from the babes. They're always picking him up and cuddling him. He gets so much attention it's not real. Mind you he's not greedy — he makes sure he passes the really cute ones on to me."

LEFT & OVER LEAF: *Flash Job,* 2001. Neutralized peroxide on *Flash*, British Blue. J. Lynch, Galveston.

A traveling photographic exhibition of cat art recently caused controversey in New Zealand when local Maori claimed Sam Cawker was insensitively applying a traditional Moko type of design to an animal. Cawker defended the work saying that his tattoos followed the natural grooves in the cat's facial fur, but he appreciated that every culture or religion has its own deeply felt cultural values and icons that should be respected. "I guess I'm going to have to be a whole lot more aware in future," he says, and adds, "Lets hope there aren't certain patterns out there that are really offensive to cats."

[1] Jim Lynch believes that a name emblazoned on a cat gets people involved with it because they always ask why it has that name and the answer helps them know it better. Flash was born in a lightning storm.

MIRIAM McKEE

~ Artist

CLASSICAL FABRICATIONISM

"I've been accused of painting cats simply for my own aesthetic pleasure without giving any thought to how it might benefit them. What nonsense!" ~ Artist

This year Scottish fabric designer Miriam McKee is wearing big hats, big glasses and a big smile to celebrate the opening of her new design studio in London. However, in spite of her rapidly growing reputation, or maybe because of it, her work with cats attracts more than its fair share of criticism, and it really rankles. "I've been accused," she snorts, "of painting cats simply for my own aesthetic pleasure, without giving any thought to how it might benefit them. What nonsense! You have to understand that you'll never see a tartan like a fur-tartan – it's an astonishingly beautiful 'fabric.' It has a unique translucence and you'll never feel another plaid that's so smooth. Plus, the feline body can move it like you've never seen a tartan move before. The way the under check interacts with the over check as the cat runs is simply exquisite. So you see it's the cat, and only the cat, that can bring us this delight, and that elevates it in our minds and ensures that we treat it extraordinarily well. So of course it benefits!"

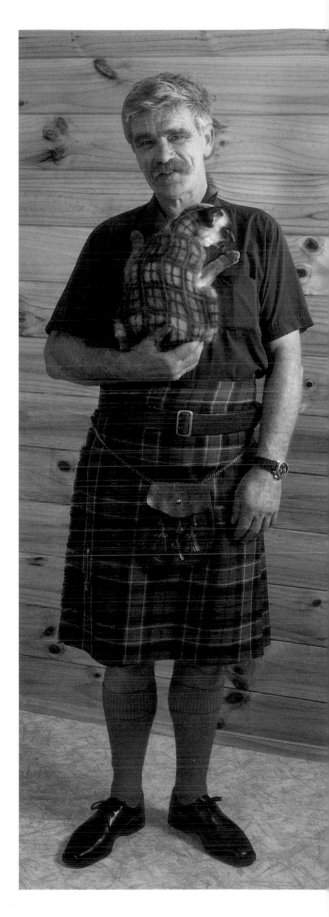

LEFT: *feileadh mhor,* 2001. Organic peroxide & vegetable dye on *Robb,* Siamese. K. McGill, Kilmarnock.

Painting tartans is very difficult. Robb was painted while asleep and took thirty half-hour sessions to complete.

RIGHT: *Tarty Puss,* 2001. Organic peroxide & vegetable dye on *Slinky Mink,* Siamese. I. McGregor, Aberdeen.

Publican Ian McGregor holds Slinky Mink. He paid £5000 for her to be painted in 2001.[1]

[1] McGregor claims that the cost of the painting was more than repaid in bets that he took with hapless drinkers who were willing to wager that there was no such thing as a tartan cat and that he didn't have one upstairs.

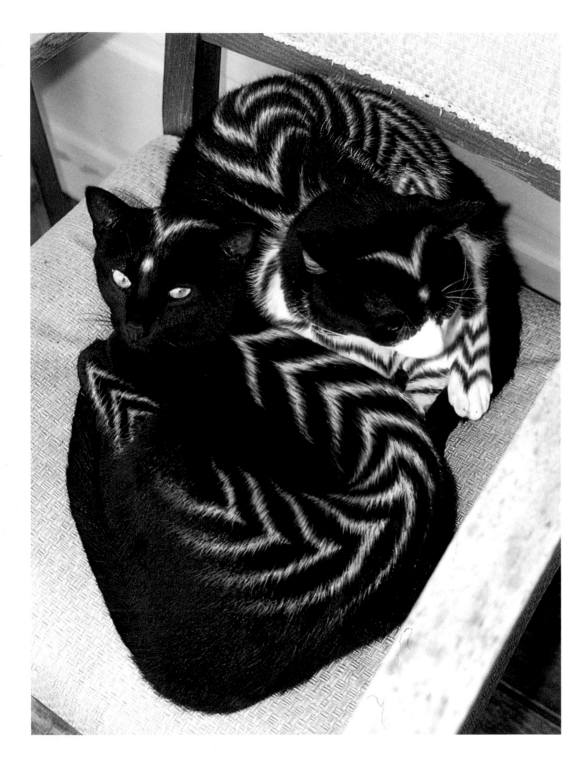

RIGHT: *Crème félin,* 2001. Organic peroxide & vegetable dye on *Ruby,* black & white moggy. I. Pen, London.

LEFT: *Crème félin de la nuit,* 2001. Organic peroxide on *Oscar,* (left) black moggy. I. Pen, London.

The idea for her stylish interlocking arrow patterns came to Miriam McKee one evening at the Savoy while playing with the feathering on her *sauce chocolat.* It was such a smooth, alluring design, she knew immediately it would perfectly complement the graceful feline form. She knew too how cats are all muscle and sinew with flexible skeletons and baggy skins which enable them to move in many different ways. So, far from any design on the cat being fixed, it would be possible for it to be pushed and pulled into a myriad of new and exciting patterns. McKee says that people who hold and stroke her *Crème félin* cats are so enthralled by the kaleidoscope of patterns that appear before them, they can't stop running their hands all over them. "Once we paint a cat like this," she says proudly, "it becomes a very, very loved cat."

But McKee has stern words for some artists who use the mobile nature of the feline canvas to produce less abstract effects. "I have had the misfortune," she says, "to see certain Indian designs of a so-called religious nature, in which Gods such as Vishnu and the like are made to perform quite inappropriate acts by moving the cat's skin backwards and forwards. The cat may be unaware of the design and it may receive a lot of attention, but I don't think that kind of cat art stands ethical scrutiny."

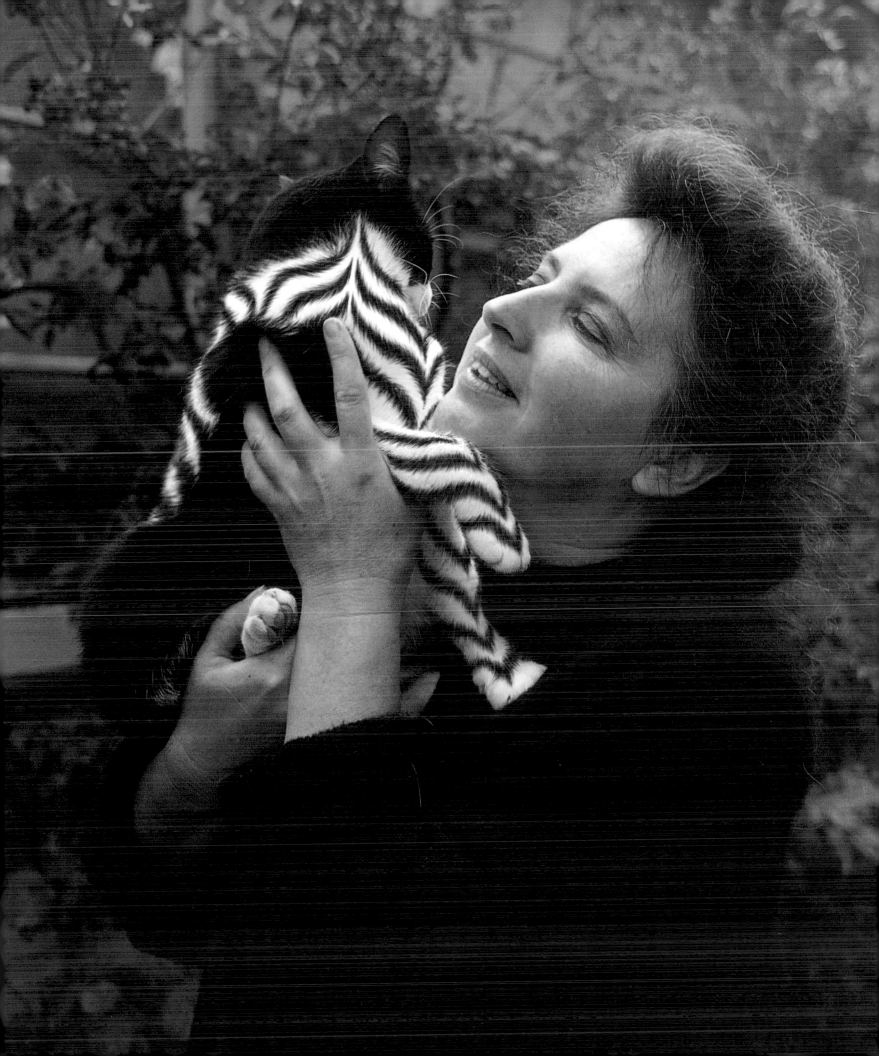

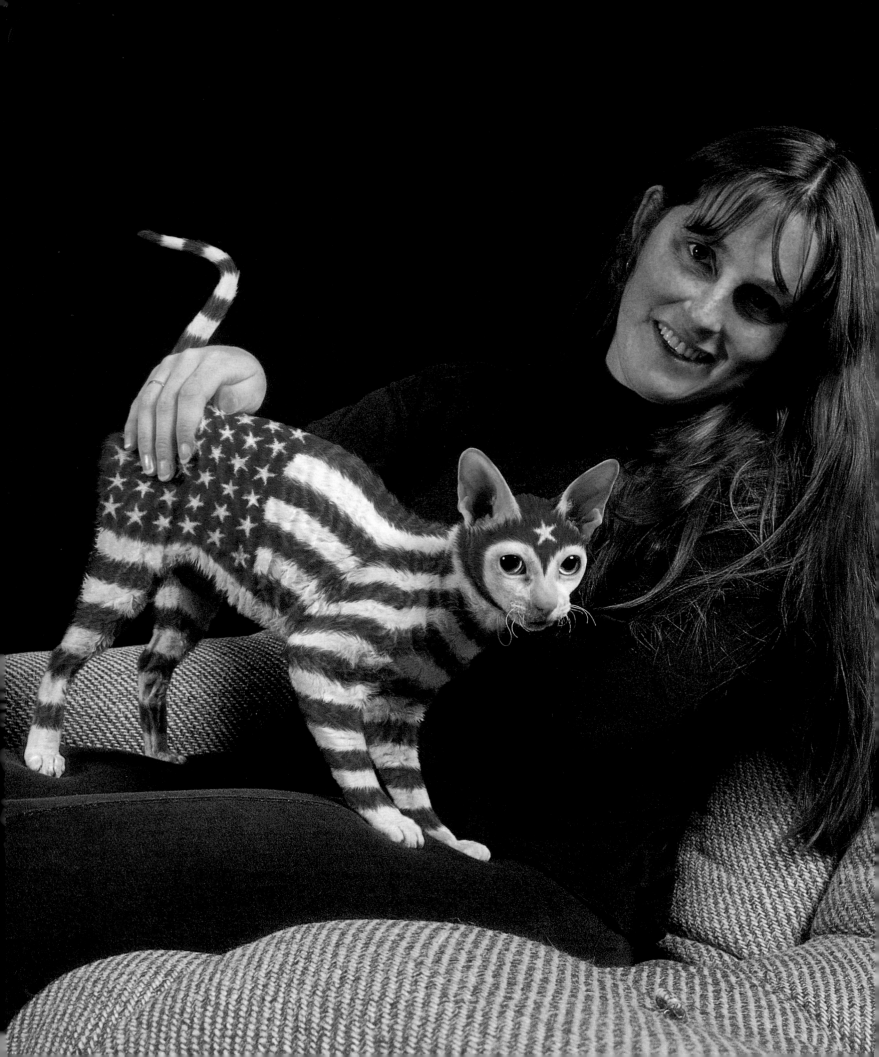

JOHN TILLY
~ *Artist*

RADICAL SYMBOLISM

"...now I relate to my cat quite differently...When he leaps onto my bed he really is my Glory Boy come to save me..."

~ Cat's Guardian

The first time John Tilly painted a cat was on his seventh birthday. That was the day the family moggy, Mitsey, was hit by a car and nearly died. On that day he decided that if he painted a big STOP sign on her, drivers would take heed and it would never ever happen again. "I used red food coloring," he remembers, "and did it while she was asleep. My parents hit the roof but I got off fairly lightly because while I'd done the 'wrong' thing, I guess it was for the right reason, and after all I was only seven." Thirty years on and some forty feline fur canvases later – including his controversial *Naked Nun*[1] series – Tilly still prefers to paint in stages while the cat is asleep, or if possible, hypnotized, and continues to insist there is a good reason for doing it. "The work," he says, "has to elevate our perception of the cat. I won't do anything that's merely aesthetically pleasing or designed to convey some political message."

This is borne out by Tinkle's guardian, Raewyn Carter, who commissioned the $7,000 work. As she noted at the time, "By giving Tinkle a blue cap with a star, he's cleverly transformed my rather boring flag idea into a dashing costume so that now I relate to my cat quite differently. Suddenly he's my super hero. When he leaps onto my bed he really is my glory boy come to save me and save the world. It's helped get me through a lot of negative self-perception and I now experience a much deeper feline connection."

LEFT: *Glory Boy*, 2001. Vegetable dye & hair coloring on *Tinkle*, Devon Rex. R.Carter, Orlando.

John Tilly's clever use of fur structure to heighten design is one of the features of his work. Here, the alignment of red stripes across the undulating Rex fur gives the flag a wavy appearance as though rippling in the wind. This helps to intensify the rich symbolism contained within the work. As art critic Betsy Cross noted, "The striped prison-like clothing being worn by this very thin cat in conjunction with a blue skull cap adorned with a white star clearly symbolizes the heroic yet confused Post-Zionist struggle against the Americanization of Israel."[2]

[1] *Cross, B.* "...Five young black and white cats with stylized human erogenous areas airbrushed in pink, can be viewed playing together behind a glass screen in the vestry." *Exhibition Catalog, Santa Rosa, 1999.* [2] *ibid.*

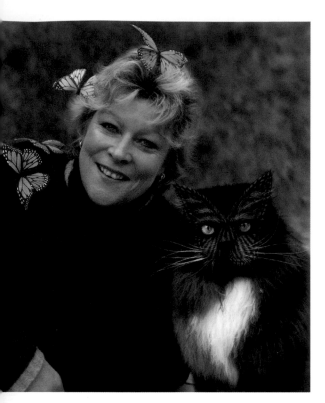

FLAVIA VENEZIA
~ Artist

TRANSMUTATIONAL MANNERISM

"She was the one woman in Italy who had the foresight, the felines and the fiscal flamboyance to make my dream come true."

~ Artist

ABOVE: Marina Mantovani, cat painting patron and president of the Milan Lepidoptera Society, with her cat, Archimedes.

RIGHT: *Moth Man,* 2001. Vegetable dye on *Archimedes*, Persian. M. Mantovani, Milan.

OVERLEAF: *Pansyflies,* 2001. Vegetable dye on *Boadicea & Nefertiti*, Persians. M. Mantovani, Milan.

One critic described Venezia's painting of *Moth Man* as startling and said; "...by blending ears with face the ears are lost and become part of a mask thrust forward in such a way that the head line takes on a human quality. What emerges is neither cat nor moth but a man with smoldering eyes" [2]

Flavia Venezia, who hails from New York, thinks she was quite young, maybe seven or eight, when she discovered that the outline of a butterfly could be turned into a cat's face simply by adding a couple of eyes. At art school in Florence, she gave the concept new meaning by pressing the wings of dead moths onto damp paper to leave behind powdery gold feline faces which she adorned with glowing eyes and shining whiskers. From there, the final, inevitable transmutation – the painting of butterflies onto cats' faces – needed only the right cats and the right guardians. They came two years later in the form of the charming Marina Mantovani and her five cats: Aristotle, Archimedes, Boadicea, Nefertiti and Fluff. "She was the one woman in Italy who had the foresight, the felines and the fiscal flamboyance to make my dream come true," says Venezia. [1]

That dream was to explore the transmutation of feline, via the chrysalis of art, from furry caterpillar to winged moth, from immutable fat cat to ethereal fairy of the night, now fully realized and set free to follow the light. In the process she was to discover powerful new beings and strange botanical forms emerging from the edges of her intricate fusions. Much of their impact she claims, arises because the cat as canvas is not designed to be seen in a static state. Rather it moves and so engages surreptitiously, emerging from the bushes and dashing across our path or rushing forward to rub languorously against our sensibilities.

[1] Translation by *Patrick King*. [2] *Wilson, M.* Mannerism, Post-Mannerism and the Transmutational Mannerists. *Journal of Contemporary Italian Art, Vol. III, 2002.*

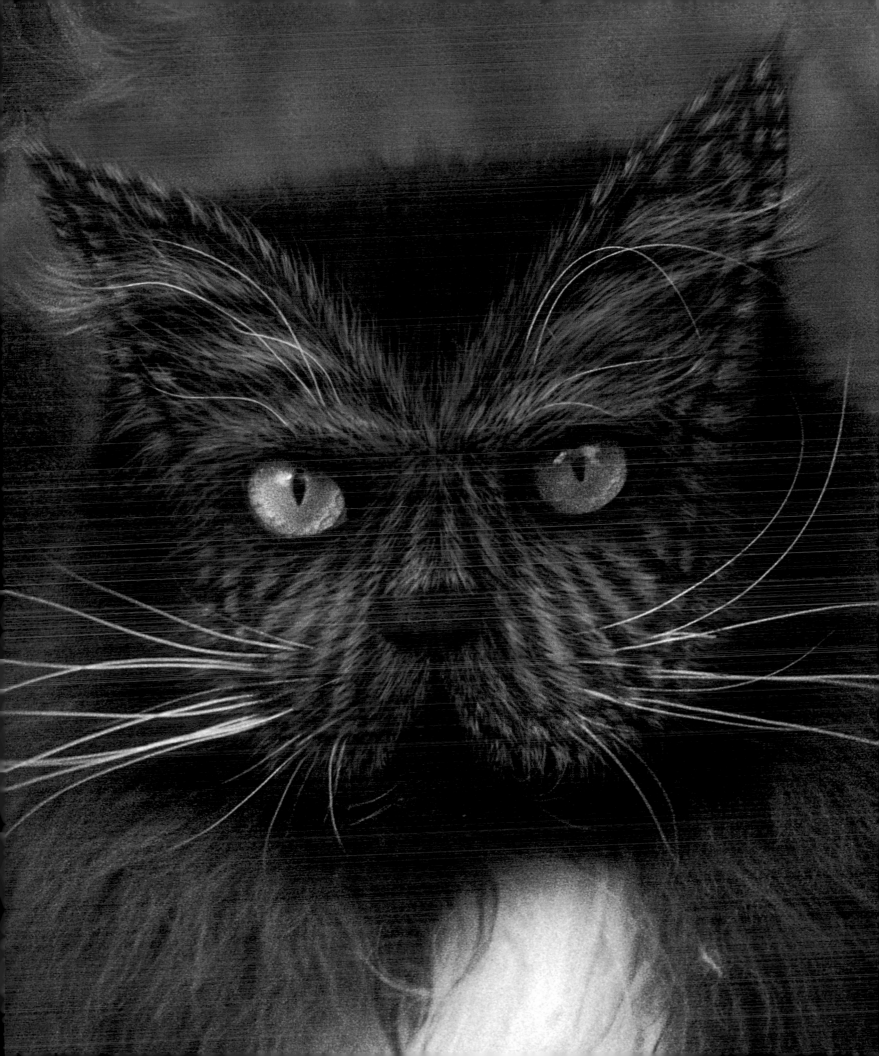

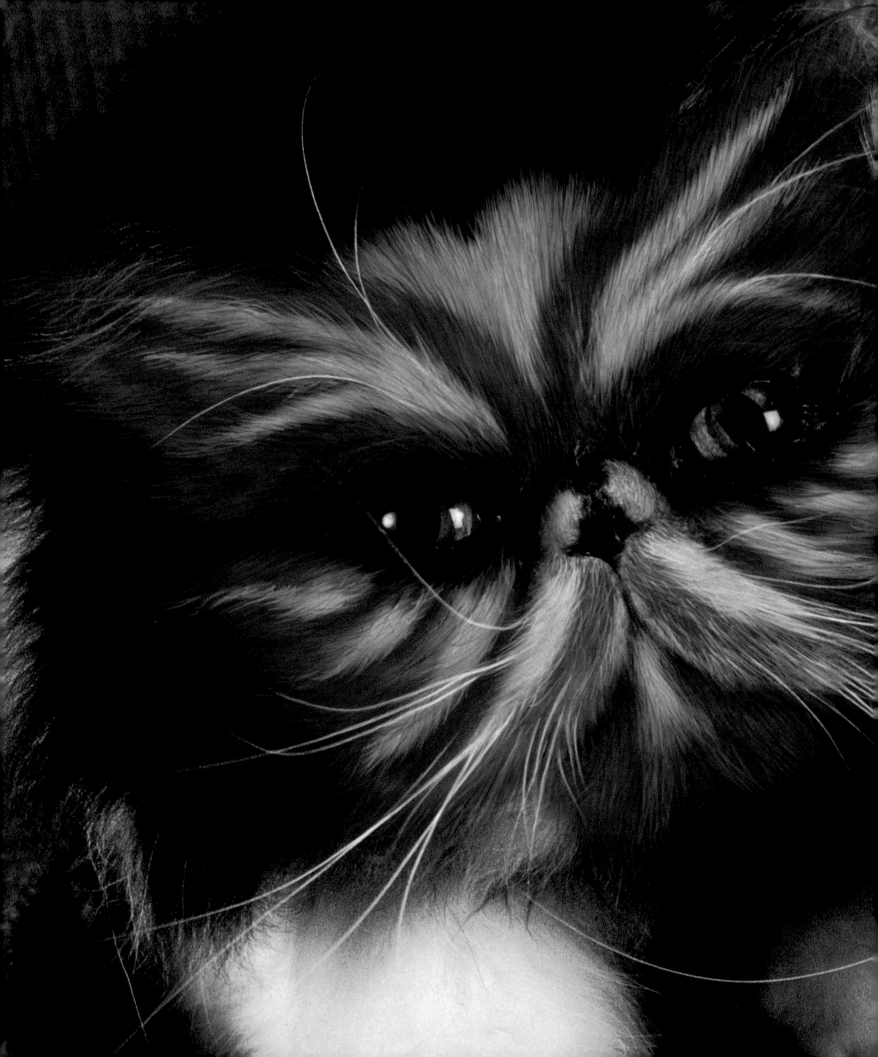

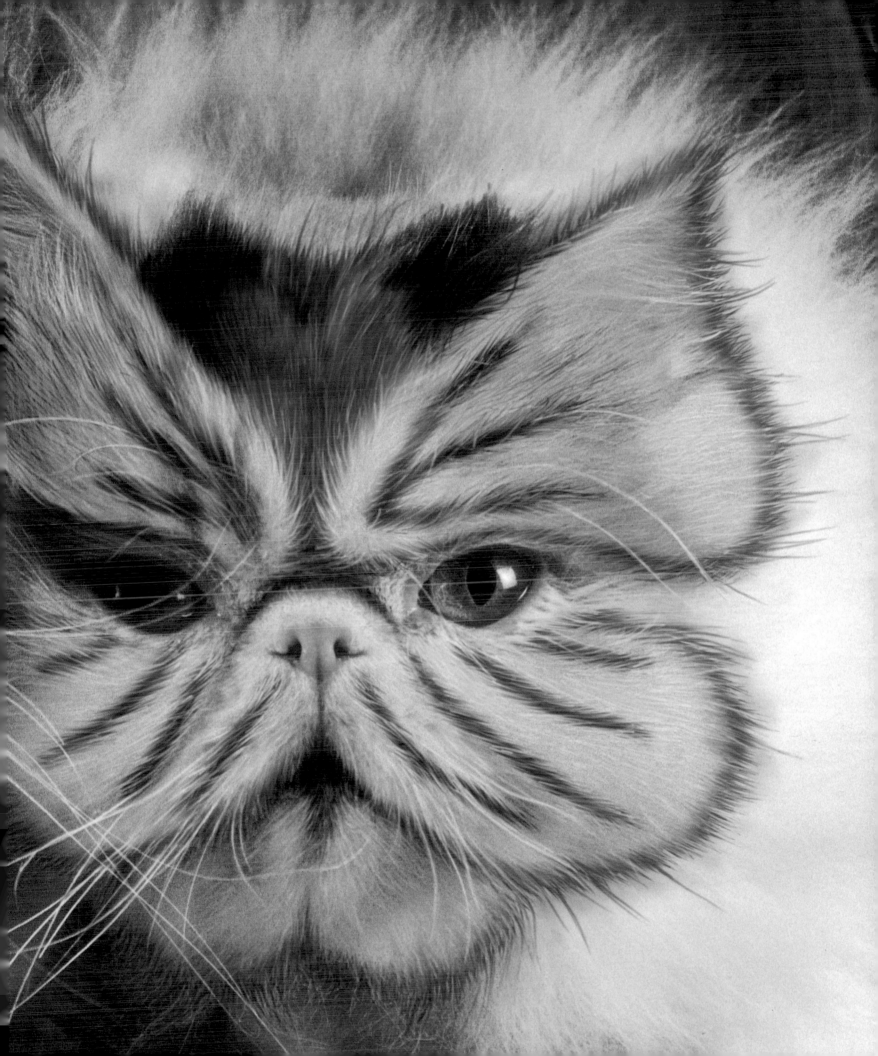

JACKIE & JAY BLOOMFIELD
~ Artists

RETRO-EXPRESSIONISM

"We think you should be able to get into cat painting without having to put across some deadly serious message every time."

~ Artists

RIGHT: *Mr. Green Eyes,* 2001. Vegetable dye on *Big Boy*, Persian. J. Brown, North Beach.

When *Mr. Green Eyes* was exhibited at a Sausalito Gallery in 2001, it met with reviews suggesting that it contained negative feline messages. For example, local critic Dena Koplos said, "The artists' depiction of a green-eyed purple cat as a metaphor for monster – with specific allusion to the 1958 hit tune, *The One-Eyed One-Horned Flying Purple People Eater,* (Sheb Wooley's clever description of television) – draws a clear parallel between the socially noxious effects of television and the environmentally destructive consequences of feline-avian conflict in the urban context." [2]

Jackie and Jay Bloomfield, twins from San Francisco, started painting their own cats when they were twelve – about the same time they started to color their own hair. Now that they're fully qualified as hairstylists and cosmeticians, they also offer a professional cat painting and styling service out of their small Bayview salon. They're not short on energy these two, and together with their view that cat painting should be fun, it means they're not short on clients either. "We think you should be able to get into cat painting without having to put across some deadly serious message every time," says Jackie. "If you're a member of A.E.T.A., which of course we are, your work has to benefit cats or upgrade them in some way, but that's not hard. We put out this flyer, *25 Good Reasons to Have Your Cat Painted,*" she says, and rattles off the first few bullet points. "A painted cat is less likely to be run over, or lost, or stolen. It gets heaps more love and looks so good you forgive it for destroying the furniture."

Most of their cat painting work is for celebrations of one kind or another – birthdays, weddings, Christmas, Halloween – and they've even done a Tabby in a black tie for a funeral.[1] But creating on the feline canvas has not been without its problems. "Just recently this woman wanted her cat painted a very soft pink for her son's coming out party," says Jackie. "Except that it turned out bright purple," exclaims Jay. "And since we'd given it a warm rinse dye, there really wasn't a lot we could do about it.

[1]Their *Amazing Technicolor Dream Cats*, done in ten vivid colors, have become increasingly popular for school nativity plays. [2]*Koplos, D.* The Green-Eyed One-Tailed Spying Purple Parrot Eater. *L.A.Art Times, 2001.*

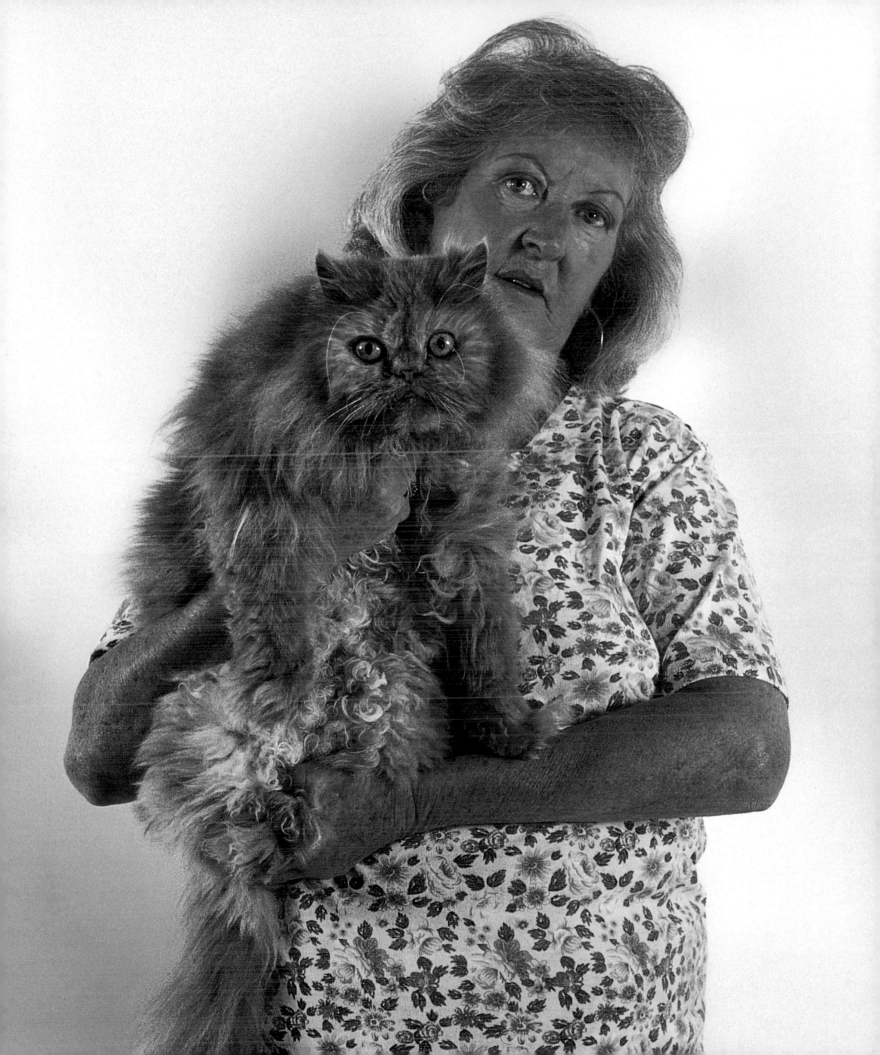

Poor thing, she burst into tears when she saw him and we thought, 'wow this is going to cost us.' But it turned out she was crying because it was just like the purple shirt her husband had been wearing when she first met him, which was also the first time she'd tried a kiwi, and since he had green eyes we knew just what to do. That's how *Mr. Green Eyes* happened." "Another time," says Jackie, "a young woman wanted her cat painted blue to go with her blue mood after her boyfriend had dumped her. Then right after we did it, she met this other really hot guy and wants the cat fluorescent red. Well Jay had the idea of just doing the tips red so that when she stroked it she'd know that blue was always waiting underneath. It looked sensational and now duotones are one of our most popular styles." [2]

[2] Cats like to wash themselves after being dyed, so it's important to blow-dry them before they can lick the dye off. For this reason the Bloomfields insist that clients get their cats used to the sound of the drier beforehand.

LEFT: *Hot & Cold,* 2001. Vegetable dye on *Billy*, Persian. D. Hunt, Potrero.

ABOVE: Dawn Hunt loves to take Billy, her duotone Persian, for rides so she can enjoy the changing colors that ripple though his fur. She also admits to delighting in the interest he creates and the many positive comments she receives on his behalf when they go out together.

DONNA McLEAN
~Artist

METAMORPHIC INVERTISM

"Examining your cat for hidden art is the first stage in forming a deep relationship with it." ~Artist

"When you search for a needle in a haystack," says Mademoiselle Samoris in Guy de Maupassant's short story, *L'Obsession*, "you come to know the haystack," It was this principle that triggered Donna McLean's great interest in small invertist designs on cats. In Maupassant's story, Mademoiselle Samoris contracts a Parisian miniaturist to make a tiny motif somewhere on her body just prior to each tryst, and then sets her lover the task of finding it – *avant consommation*. In similar fashion, McLean painstakingly creates inverted, difficult-to-find images on cats in order to enable their guardians to gain an intimate knowledge of the feline physique by searching for them. "Examining your cat for hidden art," says McLean, "is the first stage in forming a deep relationship with it."

Her specialty is painting minute figures on the roots of the fur to create new environments. For example, depicting Little Red Riding Hood in one part of the body and the wolf in another, transforms the cat's entire fur mass into a vast forest and is a favorite with children who love searching for fairy-tale characters amongst the "trees." Sometimes they're so small and well-hidden that they defy discovery and only reveal themselves when they eventually grow out and magically appear high up in the branches. But McLean's oeuvre is not confined to message via process. Her desire for us to engage directly with the image itself is clearly demonstrated in works which meld the human face with the feline and remind us that the cat's face is mute – unable to convey even a smile or a frown.

RIGHT: *The Smiling Troll Looks Out From Under the Bridge,* 2001. Vegetable dye on *Marika*, tabby moggy. G. Thyne, Las Vagas.

The difficulty of viewing McLean's work in exhibition has resulted in few reviews, but amongst the cognoscenti it is almost revered. "It is not the viewing of the art that concerns McLean," wrote well-known critic Ian Weedley, "but what is achieved in the process of discovering it...It is only with hindsight when you have finally found the image – and along the way delighted in Marika's purring patience – that you realize the cryptic title has cleverly alluded to its position all along. 'The bridge,' of course refers to the bridge of the cat's nose." [1]

[1] *Weedly, I.* Homage to McLean. Journeys Through the Feline Forests of Enlightenment. *Journal of Applied Animal Aesthetics, Vol. VI, 2000.*

DAVID DONKESLEY
~ *Artist*

FILAMENTALISM

"Cats are incapable of self-reflection…and…don't knowingly exploit us. We in turn must knowingly not exploit them…" ~ *Artist*

Creating a new understanding of cats by painting their whiskers has to be a tall order, but that's exactly what David Donkesley from Toronto has set out to do, and, it seems, with some success. His lectures with live painted cats are popular with animal welfare organizations throughout Ontario and he was recently awarded the Fur Cross, A.E.T.A.'s highest honor. Because they're so sensitive, whiskers are the most difficult part of the cat to paint[1] and need to be slightly numbed using a special procedure Donkesley has developed called Vibrissae Base Probing. This involves gently massaging the base of each whisker with the pointed end of the brush, which desensitizes it just long enough for the careful application of dye.

One by one the filaments are numbed and painstakingly adorned with a series of evenly spaced and alternately colored dots. When finally completed the combined effect is startling. Once the whiskers are brightly lit and moving, the dots interact with each other to create the illusion of a myriad of tiny lights, dancing in front of the feline face like a kind of suddenly-revealed force field or aura. The cats seem as unconscious of the effect as they are of the insects that Donkesley draws on their faces – huge long-legged creatures clamped between their eyes which people want to brush off yet cats are unaware of. But this is the artist's message. "Cats are incapable of self-reflection," he explains, "and are therefore innocent beings that don't knowingly exploit us. We in turn, must knowingly not exploit them, any more than we would a child."

ABOVE & LEFT: *Aura,* 2001. Vegetable dye on *Katja,* tabby & white moggy. P. Woods, Scarborough.

OVERLEAF: *Innocence,* 1999. Organic peroxide on *Svengali,* Persian. B. Sumner-Burton, Toronto.

Of the five serious filamentalists exhibiting in North America today, Donkesley's work stands out as the most innovative, and one critic believes that it is also portentous; "Donkesley's colorfully striated whiskers that transform these feline filaments into the fine translucent tentacles of some newly discovered sea creature, are also reminiscent of D.N.A. strands – surely a clear warning that painted mutation may be the precursor to genetic modification."[2]

[1] In order to help artists who get unwanted paint on fur, Donkesley is writing a treatise on natural solvents called; *Getting It Off. When Cat Painting Goes Wrong.* [2] *Burstyn, B.* Exhibition catalog, North York, 1999.

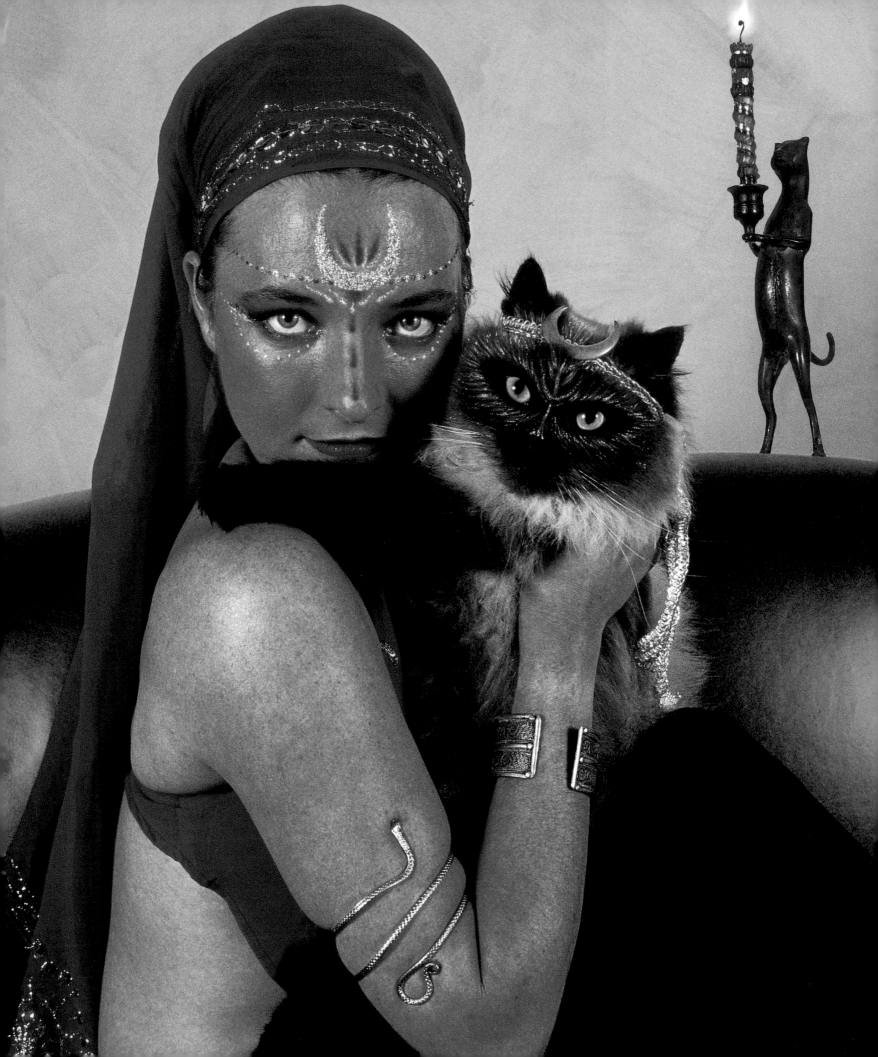

ANDREA HEINZ
~ Artist

DEIFICATIONISM

"The artist manages to… imbue these feline eyes with all the ruttish intensity of a masked boudoir bandit." ~ Critic

Most of Andrea Heinz's cat painting commissions come from Charles Cain, a therapist in Phoenix who uses Egypto-Feline Deification Infusion Training (EDIT) to help people heal themselves emotionally. EDITing, which has a popular following in Arizona, claims to be a powerful method of releasing excessive anxiety and raising one's spirits. It works by painting cats to represent ancient Egyptian gods and goddesses and then guides trainees to interact with these felines in such a way that the pure, non-human, non-judgemental spiritual force of the deity can infuse them with its healing power.

Take the case of Mary Cronin, who used Cain's therapy to help her come to terms with her fertility problem. She was assigned Casper, a beautiful Birman that Heinz was asked to paint as Thoth the god of the moon, "with dominion over the seasons and the female menstrual cycle." Thoth is normally depicted with the head of an ibis, representing wisdom and wears a crescent moon signifying new life. Heinz painted the shining wings of the ibis around his eyes to symbolize "wisdom released," and the three-pronged trident representing parted legs with the central life force traveling between. Cronin was similarly adorned so she too could assume the mantel of giver and taker of fertility and thereby overcome her feelings of powerlessness. Exercises included crouching over Casper and gently pressing her stomach down on him until he brought her symbolic release by creeping out between her legs.[1]

LEFT: *Thoth,* 2000. Vegetable dye on *Casper,* Birman. C. Cain, Phoenix.

In spite of being given a defining brief for her work, Heinz's bold deifying designs seem able to satisfy and transcend the very precise and therefore restraining requirements of such a therapeutic commission. As art critic Henry Adams pointed out: "The artist moves beyond the symbolic requirements necessary to transform cat into god and manages to imbue these feline eyes with all the ruttish intensity of a masked boudoir bandit."[2]

[1] Cronin credits the birth of her son Thoth, in 2001, to her EDITing work with Cain.

[2] *Adams, H. Symbiotic Symbolism and the Feline Ethic. The Journal of the Embellished Cat, Vol. II, 2001.*

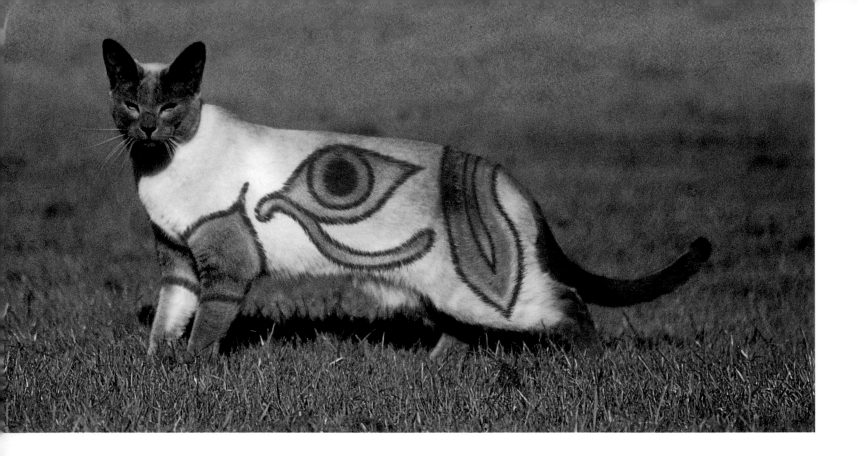

ABOVE: *Udjat Cat,* 2001. Vegetable dye on *Rocky,* Blue Point Siamese, C. Cain, Phoenix.

RIGHT: *Ra,* 2001. Vegetable dye on *Jane,* Siamese, C. Cain, Phoenix.

Andrea Heinz's commitment to cat art extends beyond her own work to budding cat painters throughout the U.S.A. Each year she teaches young adults at the Chicago Cat Art Foundation's summer painting camp and takes Rocky and Jane along as models. In 1999 the program was embroiled in controversy when it was found that some students were using euthanized stray and breeder-reject cats from veterinary clinics to practice on. While the ethics involved were far from clear-cut the practice was banned in the interests of public relations.

To help Ryan Swain (seated) overcome his fear of an abusive father, he is given the mantel of Ra, god of the sun and Great Creator. Therapist Charles Cain (standing) adopts the role of Pohken, Ra's high priest, and where necessary assists with the *pujo,* the magic rod of power and the ceremonial *dhida* or flail. Jane, a very communicative Siamese, is cast in the role of cat-goddess Bastet, the traditional protector of Ra. Using temporary dye, stencils and an electrostatic airbrush, Andrea Heinz paints Jane with the symbol of the *udjat,* the all-seeing eye[1] and adds three protective amulets, one around each foreleg and another over the base of the spine.

Each session begins with a meditation to allow the trainee to become fully infused with his character. Once this has been achieved, Pohken waves the *pujo* up and down and swishes his *dhida* under the feet of Ra to represent the attacking serpent, who in turn symbolizes the cruel father figure. Ra is transfixed with terror, just like Ryan was as a child, but this time there is help at hand. Hearing the swishing of the serpent, Bastet leaps off her altar and attacks its writhing form, biting and clawing at it until Pohken allows it to lie still. This process must be repeated many times and if Jane tires, her brother Rocky is brought in to take over. After twenty sessions Ryan no longer feels frightened by the approaching serpent because he knows that Bastet will always protect him.

[1] Heinz's 2001 report that cats painted with the *udjat* seem to catch fewer birds than those without, has led to a grant from the North American Ornithological Protection League for her to carry out further research.

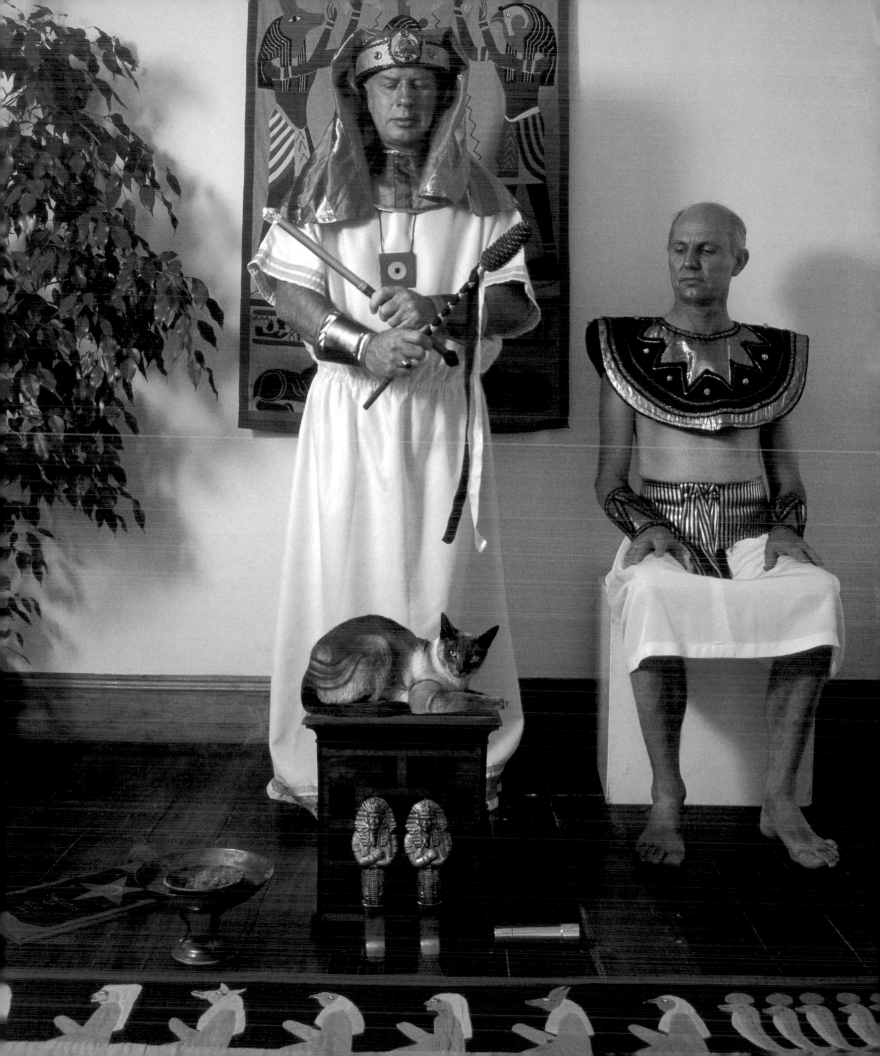

PATSY ROTH
~Artist

AVANT FUNK

"Unless we treat cats with respect and stop regarding them as our playthings, we'll never even begin to understand them."

~Artist

Patsy Roth is a woman with a mission and a knack of inspiring others to join her team. Roth typically puts in what she describes as "solid eighteen-hour days" painting cats and taking them all over California to promote her Cats Behind the Mask organization which boasts a membership of twenty-five voluntary helpers. The initiative seeks to provide a ready supply of painted cats and people who will exhibit them wherever and whenever possible, in order to spread the "mask message." According to Patsy Roth these cats help people understand how easy it is to allow the painted mask to change their perception of the cat behind it. "When folks see a smiley cat that looks like a feline member of a minstrel show," she says, "their first reaction is to say, 'oh how cute' and then they realize that they've just stereotyped the cat in the same limiting way that black people were caricatured by the Minstrels."

Whether or not Roth's methods work to change attitudes, she is not alone in voicing concern about the way commercial interests have promoted an overly cuddly image of the domestic cat. Animal welfare groups like R.A.C.E.S.T. and C.R.O.K.[1] have campaigned vigorously against pet shops that stock eye-shades, tuxedos and tiaras for cats, along with wedding dresses "for felines in love." "How sick is that?" sneers Roth and adds, "Unless we treat cats with respect and stop regarding them as our playthings, we'll never even begin to understand them."

RIGHT: *This Is Not A Cat,* 2000. Organic peroxide on *Satchmo,* black moggy. G. Bowering, Berkeley.

Since she began painting cats in 1998, Patsy Roth has concentrated almost exclusively on modifications of the feline face. Her works tend to be simply drawn monotones without embellishment of line or color and Roth claims they evoke positive responses from the public at exhibition. However, her obvious and rather didactic titles have allowed reviewers little room for interpretation, resulting in a generally dismissive response typified by comments like; "...this work is long on angst and short on aesthetics." And, "...not art statement but mission statement."[2]

[1] R.A.C.E.S.T: Raise Awareness of Cats Extra-Sensory Traits. C.R.O.K: Cats Rule OK.
[2] *Homer, W.* Blue In The Face. *LA Art Times, September, 2001.*

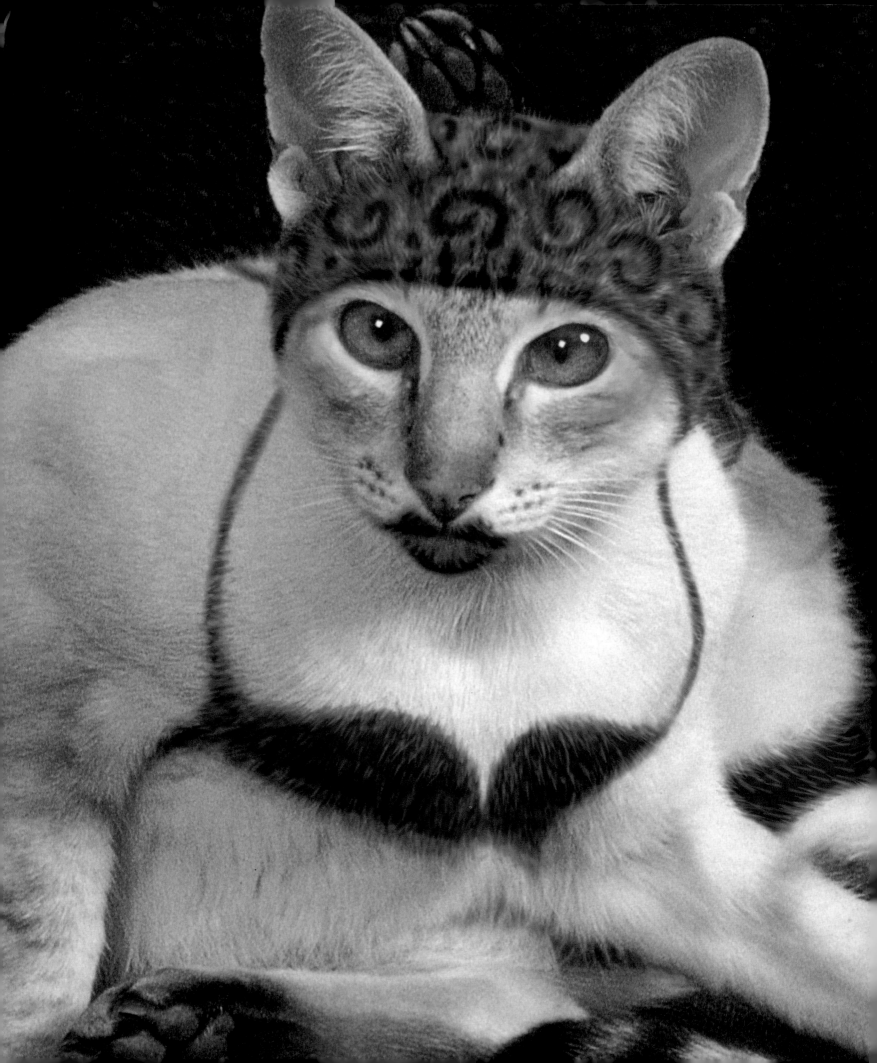

ALEX BRASCH
~ Artist

RETROMINGENT EXPRESSIONISM

"Now they're buying cats, painting them and flicking them off to the gilt-edged gullible for big bucks." ~ Artist

Being told in 2001 by an animal liberation group that his cat paintings could incite humans to engage in unseemly acts with felines is not the worst thing Alex Brasch has heard about his art. Much worse, he says, was a recent review which stated his work was mainstream. He thinks cat painting is now becoming so cluttered with exhibitions and artists that it's increasingly difficult to stay relevant and ahead of the pack. "All these wannabes are pushing the limits just to get the kudos – and the cash," he says, and claims that artists are no longer content to paint people's cats. "Now they're buying cats, painting them and flicking them off to the gilt-edged gullible for big bucks." To say nothing of the spin offs: "complete cat-painting kits, cat-painting coloring books and even garish Colorcats® for the kids to cuddle. Frankly I think it's time to quit."

But Brasch is showing no sign of opting out and every sign of creeping closer to the edge. His *Real Charlie, 2002,* with its trick squirting rose (see page 96) is a good example and so is *Tutu Much, 2002,* in which a black and white cat is given a small black moustache while its rear end is painted with a bright red tutu emblazoned with white swastikas. Whatever he does, it seems likely that Alex Brasch's work will continue to elicit a variety of responses ranging from exultant praise to contemptuous ridicule, with a lot of nervous speculation in between. The strength of his work will always lie in its outré sense of humor, its forward-looking retromingency and its complete lack of any obvious purpose.

LEFT: *When Puss Comes To Shove,* 2001. Vegetable dye on *Joyce,* Siamese. V. E. Greenleaf, Los Angles.

Critic Ed Field, who once described Brasch as, "the Joanne Gair[1] of cat painting," wrote, "There is something decidedly peasant about this work [left] – the red curlers, the skimpy undergarments, the over-reliance on lipstick and rouge. One gets the sense of a slightly deranged Bulgarian check-out clerk caught off guard, perhaps by a son or a brother, (certainly someone who will never understand) while attending to her intimate toilette before a night out on the town. There is such an unusual poignancy in this painting that we are left wondering whether Brasch himself may have experienced a boyhood in Sofia."[2]

[1] Gair is best known for her painting of Demi Moore's naked body which appeared on the cover of *Vanity Fair.* [2] Field, E. Retromingent Expressionism, The Balkan Experience. *The Journal of Cat Art, Vol. IX, 2001.*

SELECTED BIBLIOGRAPHY

ADAMS, H. 1999. **A.E.T.A. Rules of Conduct.** *Revised 1999.* Nine Tails Press, New York.

BRÜCKNER, B. 2002. **Bridget's Dos and Dont's of Cat Painting.** Verlust Verlag, Frankfurt.

CAHTIB, B. 1999. **Simply Unfurgetable.** *The Recollections of an Indian Cat Painter.* Moojo Publications, Delhi.

FOSTER, F. 2000. **Brushing Up On Cats.** *A Brief History of Feline Art in North America.* Catwick Books, Montreal.

GERDTS, A. 2001. **The Cat As Canvas.** *An International Index of Cat Painting Workshops and Exhibitions.* State of the Art Publications, Philadelphia.

LEVIN, G. 2000. **No Frames Art.** Goldsworthy, Carson, Baron & Brückner. New Art Publishers, London.

MARTIN, O. 2001. **Puddy Tats.** *25 New Feline Fur Tattoos From 'Frisco.* Swallow Press, Cambridge.

RATHBONE, P. 2001. **The Tenth Life.** *The Preservation and Display of Our Painted-But-Departed Feline Companions.* Taxidermy Press, Edinburgh.

REICH, S. 2002. **Purrmutations.** *Fifty Positive Ways To Redesign Your Cat.* Peacock Press, Washington.

SCOLL, S. 2002. **Financially Feline.** *Starting Up A Profitable Cat Painting Business From Your Home.* Entrepreneur Books, Dublin.

SILVER, B. BUSCH, H. 1994. **Cat Artists and Their Work.** Ten Speed Press, Berkeley.

SPRINGER, P. 1998. **Deontology Versus Utilitarianism.** *Bio-ethics From a Feline Perspective.* University Press, Seattle.

VAN DE VELDE, C. 2001. **Cat Painting Master Class with Zeno Baron.** High Speed Press, San Francisco.

WOOD, P. 2002. **An Illustrated History of Japanese Fur Painting Techniques.** Harrison Publications, Berkeley.

WUNDERLICH, R. 2001. **Mad Dog's Breakfast.** *Ten Things Dogs Do To Mess Up Their Art.* Fetch Press, Boston.

RIGHT *Real Charlie,* 2002. Neutralized peroxide & vegetable dye on *Burger,* ginger and white moggy. G. Tate, New York.

This controversial work, which cost stockbroker Gordon Tate $16,000, is a good example of Retromingent Expressionism. "It perfectly sums up my feelings about Hollywood," he says.

ACKNOWLEDGMENTS

Planning, research, photography, and writing for this book have taken four years to complete. We are deeply indebted to the many people who have given so generously of their time and knowledge during this period. In particular we would like to mention Patrick King, Paul Sulzberger and Marina Norris for their help with translation; Martin O'Connor and Melissa da Souza for their editing expertise; Peter Springer, president of the United States division of A.E.T.A. and his secretary Karina Kurz for their advice and help in putting us in touch with member artists; John Berryman for supplying the photograph of his father and Philip Wood of the Berkeley Feline Art Foundation for his faith in this project and his ongoing support. Finally we would like to thank our partners Melissa and Brian for bestowing on us the ultimate gift – a love for both what we do and who we are.

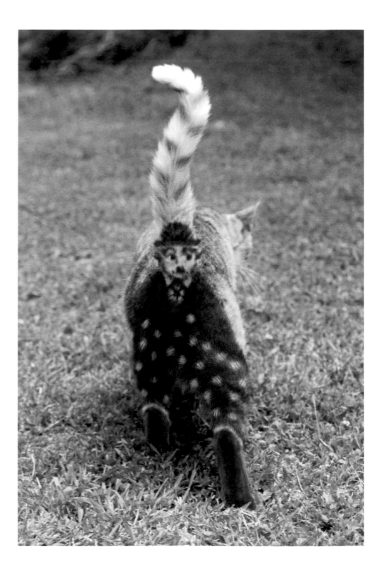